THE COMPLETE BOOK OF
PHOTOGRAPHING
BIRDS

THE COMPLETE BOOK OF PHOTOGRAPHING BIRDS

by

Russ Kinne

with an introduction by
Roger Tory Peterson

AMPHOTO
American Photographic Book Publishing
An imprint of Watson-Guptill Publications
New York, New York

DEDICATION

This book is wholeheartedly dedicated to:

—those who have become intrigued by the flight of a bird and
 enchanted by its beauty: those who have become birders.

—those who have discovered the joys and challenges of photog-
 raphy.

—those who have combined these two activities into a truly
 super sport (sometimes also called a mania, vice, or obses-
 sion).

—to one who has done all this and who also has inspired me
 and millions of others: Roger Tory Peterson.

—and, especially, to Jane and Casey.

First published 1981 in New York by Amphoto: American Photographic Book Publishing,
an imprint of Watson-Guptill Publications, a division of Billboard Publications, Inc.,
1515 Broadway, New York, NY 10036.

Library of Congress Cataloging in Publication Data
Kinne, Russ.
 The complete book of photographing birds.
 Bibliography: p.
 Includes index.
 1. Photography of birds. I. Title.
TR729.B5K56 778.932 81-12761
ISBN 0-8174-3692-8 AACR2

Manufactured in the United States of America

1 2 3 4 5 6 7 8 9 / 86 85 84 83 82 81

ACKNOWLEDGMENTS

I've come to believe that active wildlife photographers are always asking favors of someone or other. It's often just permission to cross a fence, or set up a tripod and perhaps lights in a garden or yard. It may also be permission to accompany a warden, ranger, or biologist on his appointed rounds, by foot, bike, car, boat, or aircraft. It may be advice on how to build some bit of optical, mechanical, or electronic gear, or a request for someone else to build it.

Now and then a photographer must ask to borrow a birdblind, canoe, hip boots, screwdriver, battery, corkscrew—whatever was left behind by mistake.

But there always seems to be *some* favor to ask, and I'm as guilty of this as anyone else. No, that's not true—I'm more guilty.

Over the years these requests have introduced me to a large number of very nice people. I can't honestly recall when any halfway-reasonable request was turned down. More often my chance acquaintances have gone out of their way to be helpful, despite the fact it didn't benefit them one whit. In many cases our joint efforts have led to warm, satisfying, long-term friendships. And with time, the list of those-who've-helped-me has grown into the hundreds, and it would take many pages to print my thanks to you all.

You all know who you are, those who have helped, and those who likely will in the future. Your hearts are in the right place, and I deeply appreciate it. Your assistance has (or will!) helped greatly in what can seem only to be a long string of zany projects. Lots of the pictures here just wouldn't have been possible without that help—and the helper should feel a stirring of pride and say "I helped produce that."

I do appreciate your help—words are inadequate—and I look forward to the next (or first) time we meet.

Thank you.

Russ Kinne

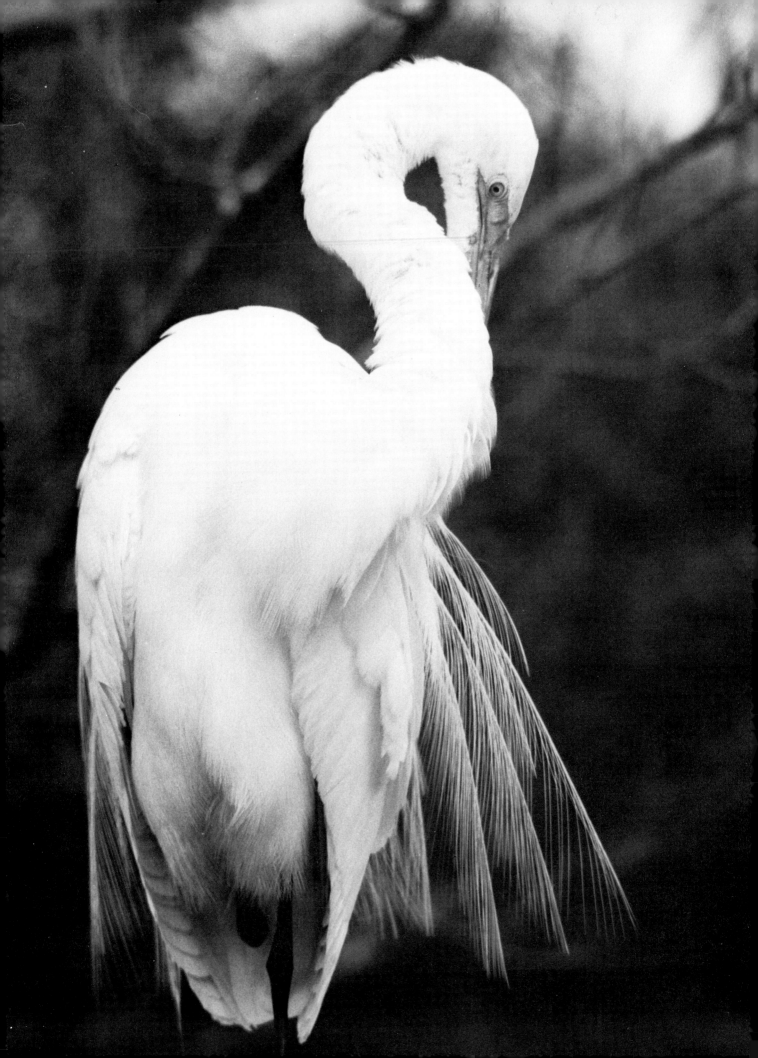

Bird photography has come of age; its devotees now number hundreds of thousands. Like the observation of birds, it can be an art, a science, a sport, or simply recreation, depending on the photographer. All of these various approaches are valid.

Birds have always played a major role in my life. Most of my professional work—painting, lecturing, writing—has involved birds or ornithology in one way or another. Recreationally, I have been drawn to birds from my earliest youth, and my greatest pleasure, still, is to take off to some remote part of the world—Africa, Antarctica, Australia, Asia—to observe and photograph them.

Countless thousands, indeed millions of people have been enthralled by birds—from the barefoot eleven year old, agog over his first view of a kingfisher, to a poet or artist transfixed by a lark or a swallow. Birds, because of their high rate of metabolism, their flight and incisive actions, are among the most vivid expressions of life; and we poor humans, despite our own accomplishments, can only watch and envy them their vitality and ability to survive in a demanding world.

Some psychologists would insist that bird photography is not unlike hunting, a remote survival from more primitive times, when every human had to hunt to stay alive. Millions still shoot for sport; others with a distaste for the taking of life (unless for the table), subconsciously enjoy the thrills of the chase by bagging their quarry with a long lens. This takes greater skill than handling firearms, but there are not as many prohibitions and limitations. There are no closed seasons, no protected species, no bag limits. The same bird can be "shot" again and again, yet live to give pleasure to others besides the photographer. The picture is the trophy, as tangible as a head of horns on the wall or a stuffed owl on the mantlepiece—and it does not gather dust.

The basic approach to all photography, should you wish your pictures to hang in exhibitions, is pictorial, concerned with composition, attractive pattern, values of light and shade, originality of concept and, when it can be achieved, emotional quality. Some critics question whether we can regard photography as a true art form in the modern sense inasmuch as "art" these days seems more concerned with subconscious comment and abstraction than it is with realism. I shall not labor the point, for my own art training was in the academic tradition.

The documentary or scientific approach is less esthetic and more functional. The field biologist is seldom without a camera. Dr. Arthur A. Allen, who for many years was professor of ornithology at Cornell, the first of many U.S. universities to of-

fer advanced work in this discipline, placed great emphasis on photography as a tool in the study of birds, a tradition that is still kept alive and flourishing in Ithaca. The bird behaviorist would be lost without photography (especially motion pictures). Pictures make it possible to analyze and reinterpret actions long after the incident; they leave nothing to faulty memory. The ecologist, publishing a paper, can often tell more about a bird's habitat with a single photograph than he could with many a wordy paragraph.

The hardcore "birder," who makes a game or sport of listing, may graduate to a Novoflex or some other 400mm lens when his binocular affords him diminishing returns and new species for his list become increasingly hard to find. He may document rarities through the lens, which is the modern substitute for the collector's gun, or he may simply build up a collection of species photographed, much like the "life list" of the birds he has seen.

In bird photography, we find many problems that simply do not exist for the news or sports photographer, the portraitist, the advertising photographer. We have a wild, free subject that will not, cannot take directions. We must fool the subject, entice it into good situations for photography. And the actions of many birds are *fast*—too fast for the eye to follow—such as the flight of a hummingbird or the stoop of a falcon. Only the super-fast eye of the camera can stop them.

At this point I wish to repeat and emphasize a warning made by Russ Kinne in his text: "It is up to you, as a student of birds and bird photography—and as a considerate human being—to make sure your activities don't have damaging or fatal results for the birds; this must be basic and primary in all your work with wild creatures." And, I might add, this is especially important when colonial birds are involved. Stay outside the colony and shoot from a blind on the perimeter, using a long lens.

For every problem in bird photography there is (hopefully) a solution. This book attempts to deal with these problems and their solutions. It may involve the use of some piece of standard photographic gear, or some bit of equipment meant for some non-photographic use, or even some gadget that must be home-made. Russ Kinne is a tinkerer, and shares what he has learned with us.

Many years ago I was naive enough to believe that nature photography could not be perfected much more. I believed that this art, craft, sport, or science—call it what you will—had attained near stability. Since that time color film has come on the market, film speeds have been stepped up and high-speed strobes have been developed commercially. Lenses of great focal length, extraordinary definition and speed line the dealers' shelves. The cameras themselves are now so sophisticated that they almost think. Ingenious systems of synchronization and remote control, fluid tripod heads, gyroscopic stablizers, and a

ROGER TORY PETERSON
INTRODUCTION

CONTENTS

thousand other accessories tempt the photographer to mort-gage his home. Today I make no predictions, knowing that not a year will pass without seeing innovations or improvements in cameras, film, accessories. Present techniques will be super-seded. The only serious limitations will be the checkbook.

Although I have probably read every book and pamphlet dealing with wildlife and nature photography, starting with the works of A. Radclyffe Dugmore and L.W. Brownell, excellent in their day (more than 60 years ago), I found that most publica-tions told me little I did not already know. A feature that makes this book a gift from heaven is the very thorough discussion of the ideal equipment and its care. Indeed, every chapter is a goldmine of "know-how." Wildlife photography by its very nature requires techniques that are not easy, equipment that is expensive, and, above all, the almost fanatic drive of the perfectionist.

The new breed of wildlife photographer tends to have an ad-vantage over those of my generation, not only because of their youth and energy, but also because they can start off with the most recent cameras and accessories on the market. More than one experienced oldtimer, aware that he is being by-passed in the struggle for excellence, has wondered why. The answer may be in his reluctance to invest in expensive new equipment and to try new methods. However, there is much to be said for knowing one's camera and lenses thoroughly, getting the most out of them and not relying on every new gadget to accomplish miracles.

I am a compulsive photographer who shoots an appalling amount of film but sells relatively little of it for actual repro-duction. However, I find photography one of the most impor-tant tools in my profession. I give many lectures with 16mm film and 35mm transparencies and could completely occupy my year in that manner if I chose; but a more important func-tion of my photography is to acquire research material for my painting and illustration. When in my studio I can project a transparency on a trans-lux screen; then there is no question as to how a bird holds its foot or how a leaf catches the light. I may even use 16mm film in this manner, projecting it through a cold quartzite lens so as not to burn out the film as I advance it one frame at a time. By doing this I can better understand the leg action of an osprey or the wing motion of a duck or a heron.

Although I use photographic reference material constantly, I seldom make a literal copy. That would be pointless; it would usurp the role of photography. The artist should use photo-graphs mainly as a point of reference. Although his work may be "representational" or "realistic" it should avoid being slavishly photographic. A Kodachrome shadow is always evi-dent in an artist's work. Our eyes are more sensitive than any color film in perceiving color in the shadows.

This brings up the inevitable query, "Which is preferable for

natural history illustration—a good photograph or a good painting? Don't they do essentially the same thing?" By no means. A photograph arrests a moment in time, a split second. There is a living immediacy, but it may not give us all the information we desire. That is why those "mystery" photographs published as a kind of guessing game in some bird magazines often remain "mysteries" to nearly everyone except the photographer whose imperfect picture leaves us with only one or two subtle clues. Although plants stay put while you maneuver composition and lighting, birds simply will not cooperate in assuming the ideal pose or fit into the ideal composition when a lens is aimed their way.

The camera is a very stubborn instrument. It has no brain of its own, and the trick is to make it behave so that it records some semblance of what you saw in your mind's eye. Not easy. The artist has more options; he can edit out, improvise, get rid of clutter, rearrange. He can draw on his past experience and introduce things into his composition. On the other hand, a photograph is a record of a split second, frozen for all time. For this reason I believe action and behavior are more accurately interpreted by the camera. When the lens captures an image there is no doubt that it records exactly what the bird did at that moment. Unlike painting, it is not subject to the vagaries of memory.

As an artist by training, I like to think that I can conceptualize a picture. I am more likely to be defeated by mechanical problems, especially exposure—after more than fifty years during which I have shot at least one hundred thousand pictures! Therefore I am delighted with this book which I shall take with me on every expedition from now on. Russ Kinne is the equipment expert par excellence. During the many years I have known Russ I have phoned him whenever I had a problem. This new book will surely save me several times its cost in phone bills.

Not only do I use my transparencies as research material when painting, but also I find them a very important asset in my writing. I wonder whether many other writers use slides as a memory jog? A picture taken in the Florida Keys recalls the glare of the beach at low tide, the color of the sand, the shapes of the tidepools, the cloud formations above the horizon. It might conjure up many half-forgotten images—"It was there that I spotted a marbled godwit pursued by a group of birders led by Victor Emanuel. . . . And what was that story about the boat people from Haiti who tried to land on the beach?"

This is no argument against notebooks. Date, time, place, species observed, and numbers of individuals should be jotted down. But transparencies can trigger many memories and recall incidental things that might not find their way into the notebook.

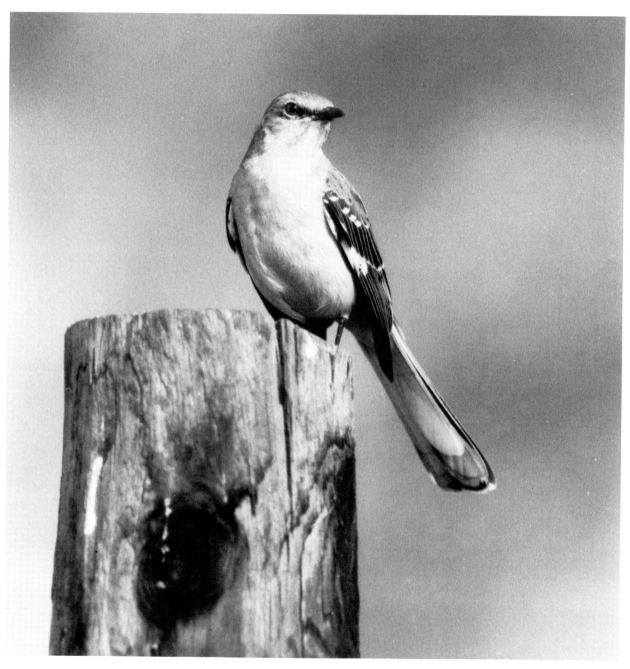

As I have repeatedly emphasized, birds are far more than ducks and grouse to fill the sportsman's bag, cardinals and jays to brighten the garden, or shorebirds and warblers to be ticked off on the birder's checklist. They are indicators of the environment, sort of an ecological litmus paper—an early warning system that tells us when things are out of phase.

Bird photographers, like bird artists, have done every bit as much as the nature writers to make the world aware of its other two-legged creatures. In so doing, they have helped lay the groundwork for the environmental movement.

ROGER TORY PETERSON

A southern mockingbird eyes the photographer from a secure perch. It was impossible to approach this bird closely, but a 600mm telephoto made it feasible to photograph from a distance and include very little background.

CHAPTER ONE
BASIC BIRD PHOTOGRAPHY

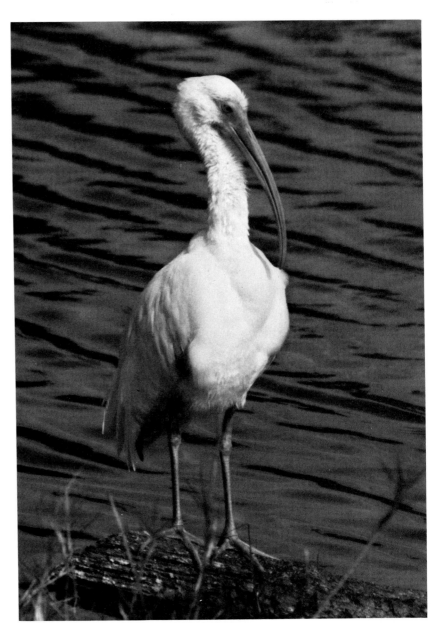

Of all the species of wild creatures with which humans share the planet, perhaps none is as fascinating as the birds. Since the days of Icarus and Daedalus, man has dreamed of flying and has watched, studied, and envied the birds.

Birds can be found everywhere, from the middle of huge cities to the vast expanses of trackless oceans. (I once saw two skuas lumbering over the polar desert, six hundred miles from the South Pole and even farther from any known dependable food source. What possessed them to go there I can't imagine.) There is hardly a place on earth where bird life of some sort cannot be found.

The variety of birds is astonishing. The adult hummingbird may be only two or three inches long; a large albatross or vulture may have a wingspread of ten feet or more. Some species weigh just a fraction of an ounce, others can weigh over one hundred pounds. The forms and colors of birds display just as much variety; virtually every hue and tint known to man can be found somewhere in the avian world.

Certainly, the birds are prime subjects—superb subjects—for photography.

In some ways photographing birds is similar to photographing anything else. In other ways it's entirely different. Lighting, subject contrast, film speed, shutter speed, exposure, and even composition are the same as if the photographer were approaching another subject, living or not. The difference in bird photography is that the subject is largely uncontrollable. A person can be told to "move over this way a little," but not a bird. (Well, you could try it, but it wouldn't work too well.) A wild bird must be wary and shy for its own survival, and it is therefore apt to move rapidly, in an unpredictable direction, at any moment.

The usual methods of model control and posing don't work with birds, but you can achieve some degree of control by using food and water to create a mini-habitat that birds like, or by setting out something designed to attract or even alarm the birds—decoys, a mirror, even a rubber snake or plastic owl. But you must know something about the birds you're after. One of the most important prerequisites of good bird photography is a knowledge of the subject. It isn't hard to pick up. Watch birds at feeders, in the park duck pond, whenever and wherever you see them. If you're after a certain species, study it every chance you get to see what particular posture or behavior will make the best picture. Talk to the people at the local branch of the Audubon Society or nature center, to park and refuge personnel, to local naturalists, amateur or professional. Read as much

The lure of birding entices numbers of people from all over the country to visit new and different areas—especially when northern states are cold and snowy and southern ones are warm and sunny.

as you can about birds to get a fuller understanding of the various species and their habits.

As you become more aware of the behavior of birds, you will also sharpen your photographic eye, mentally selecting the images that you want to get on film. In the process you can't help but become more aware of the birds' ecology—the factors in their lives and surroundings that affect their well-being. You may see firsthand what effects pollution, drought, flood, or food scarcity have on a particular species. Observation is the key to knowledge of both birds and photography.

It is up to you, as a student of birds and bird photography— and as a thoughtful human being—to make sure your activities are not damaging or fatal to the birds. This must be a primary consideration in all your work with wild creatures. This attitude is widespread, if not universal, among people who work in the field and study wildlife. As you're exposed to it, absorb it, and pass it on to others you meet and work with. Everyone benefits.

Probably the best way to start photographing birds is simply to take whatever camera you now have or can borrow and start. Fill your pockets with bread or doughnuts or peanuts, and go to the nearest park, zoo, or nature center. There will certainly be ducks or blue jays or city pigeons, starlings or house sparrows— some kind of bird life. Spend a few hours feeding them, try to lure them to the perch or area in which you want to photograph, and shoot some film. You will learn a lot. You will come back with lungs full of fresh air and with pictures you may or may not be happy with. But you will probably also resolve to go back and do better next time. You may even get some good photographs. You can't lose either way.

Always carry your camera during the stage of observation and basic study. Have it ready in the event that an unusual picture or activity suddenly presents itself. If you see a great sunset with skeins of geese crossing it, go ahead and shoot, whether or not you've read about photographing sunsets or geese. Take a chance; you might get a picture you're proud of.

The more you carry and use your camera, the better you will get to know that camera. If you use it only on holidays and vacations, it will seem strange to you each time you pick it up. If you take a dozen pictures every week, however, the mechanics of photography will become nearly automatic. Once this happens, you will be able to concentrate on watching birds and their actions and on timing your exposure to catch the peaks of action or fast-changing light. If you know your equipment, you won't fumble with the knobs on your camera while a great picture evaporates before your eyes.

In bird photography, as in all other kinds of photography, doing your background reading and study *before* you go out to shoot will make things go much more smoothly. Read the camera's instruction booklet before you get into trouble, not just when something goes wrong. Shoot a roll or two of film for practice in the backyard before tackling anything that's important to you.

There's no magic to operating a camera, but no one can do a decent job without practice. The camera can't do its best work unless and until you learn how to use it. Don't be stingy with film, and form the habit of taking at least a few pictures every week. Make your camera a close and familiar friend.

STARTING TO PHOTOGRAPH BIRDS

CHAPTER TWO
EQUIPMENT FOR BIRD PHOTOGRAPHY

There are so many types and formats of cameras available today—pocket 110s, 35mm rangefinders and single-lens reflexes, twin-lens reflexes, instant picture, and so on—that the choice can be bewildering. Although many of these cameras have their advantages in certain situations, there is really only one type of camera for serious bird photography: the 35mm single-lens reflex (SLR).

Many people tend to think of the SLR as a fairly modern development (post-World War II certainly), but that's not so. In the 1920s there was the old Folmer Graflex, once found almost everywhere and responsible for lots of good pictures, action shots included. Not much later there was the Kine Exakta, made in what is now East Germany. It was a 35mm SLR, designed by a left-handed engineer but advanced for its time and really quite a good little camera (though perchance a bit fragile; I know of two photographers who traveled with six camera bodies to make sure that they would have one or two operable ones).

What brought the 35mm single-lens-reflex design to the fore and made it popular was the introduction in the 1950s of the pentaprism, making the SLR an *eye-level* camera. Previously, the photographer had to look down into the camera in order to focus and frame a picture. The subject and motion were reversed, because the photographer was looking into a mirror. Following a moving object was difficult, and following a flying bird was impossible. The eye-level prism changed all that; the subject is seen through the viewfinder of the modern camera just as it appears in reality. Other developments and improvements followed quickly.

CHOOSING A 35MM SLR

Most modern 35mm single-lens-reflex cameras have the same features and are designed to do the same jobs. Any camera for serious bird photography should have a built-in meter with full-aperture metering, and provision for attaching a motor drive or power winder. A built-in meter allows for much faster exposure determination than a separate hand-held meter, full-aperture metering means you can focus on the brightest possible image, and a motor drive can come in handy for remote-control work or sequence photography. This narrows the field to perhaps fifty models of cameras. So how do you choose?

In many cases the choice is academic, since you'll start out with whatever camera you now have and add lenses, motors, and other extras as you go along. This does, however, lock you into one brand of camera, since it's financially disastrous to change brands *after* you've amassed two camera bodies, three

CAMERAS

There is really only one type of camera for serious bird photography: the 35mm single-lens reflex. A typical 35mm SLR is shown above, but there are many different manufacturers and models to choose from.

or four lenses, and accessories that won't fit any other brand of camera. So make sure the system to which you're adding is a good one.

When you're considering the purchase of a second camera, it's best to get one made by the same manufacturer as the one you already have. That way all the lenses and accessories will fit both cameras, and in case of a breakdown you can keep shooting with the other camera while the broken one is being repaired. You can also carry both cameras (professionals commonly carry three or four) loaded with different types of film. You may want to have both indoor and outdoor color film, regular and high-speed black-and-white film, color-slide and color-negative film, or regular color and infrared film available at the same time. A second camera body is also useful for having different lenses available for use with the same film. Then you can drop the camera with the wide-angle lens and grab the one with the telephoto lens to catch action that wouldn't wait around while you change lenses.

Starting from scratch is the best way to build up a battery of camera gear that's especially well suited to the special requirements of bird photography. If price is no object, simply pick one of the top brand names, the one that looks and feels the best to you, and go to it.

There are some relatively inexpensive 35mm SLRs available, but the trouble with buying really inexpensive models is that

they are more prone to annoying and expensive breakdowns. Prices have escalated so much in recent years that many professional photographers are saving a bundle by buying clean secondhand cameras and having them reconditioned at the factory. You can usually tell from looking at a used camera how it's been treated; if it looks like a used hockey puck, forget it.

The modern "compact" cameras have proved highly popular. I admit that they are more comfortable for hanging around your neck for several hours than heavy standard-size cameras, but I think they compromise ruggedness in favor of size and weight. If you can treat a compact camera *gently*, however, and avoid hard knocks, it could give you good service for years.

A professional photographer can't avoid giving his gear some terrible hard knocks and must have equipment that works at temperatures from above scorching to way below freezing, in dyr-as-dust deserts, and in sopping rain forests. Truly professional gear is made to be as durable as possible, and the weight and cost of such equipment reflect this. The average photographer doesn't need so much toughness, however, and one of the lighter models, designed for the stay-close-to-home market, might be an economical and practical choice.

LENSES

A basic problem in bird photography is getting a big enough image of a bird on film. There are only two ways to do this: either by moving the camera closer or by using a longer lens. Most often, the bird won't let you get closer, so that leaves only the option of long lenses (telephotos). Telephoto lenses are the backbone of bird-photography equipment.

With a lens that is twice as long—a focal length of 100mm instead of 50mm—the image is twice as big. With a 200mm lens the image is four times as large, and so on. But there are some

Most major camera manufacturers offer a complete line of lenses ranging from wide-angle fisheyes to extreme telephotos, enabling the photographer to find one for almost any type of situation.

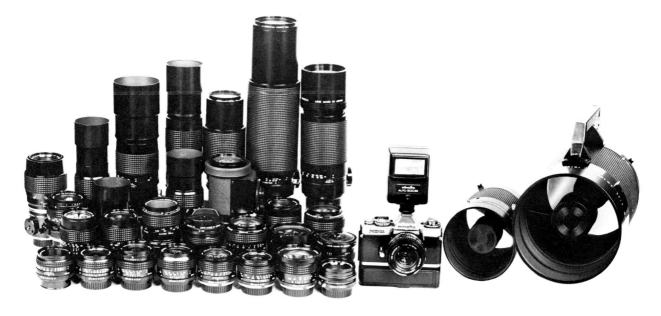

practical limits. Generally, the longer the lens, the bigger and heavier (and therefore harder to carry and hold steady) it gets. Also, as the lens gets longer, the lens speed gets slower, requiring slower shutter speeds. So, instead of racing out to buy a 1200mm lens, I suggest you start with something shorter.

TELEPHOTO LENSES

Few photographers who don't photograph birds realize that even with a big impressive lens the camera must still be fairly close to a bird subject. With a 400mm lens and a bird such as a robin, you'd have to be within 15 feet to get a frame-filling photograph. For a chickadee, make that 10 feet or so. With a 200mm lens, those distances must be halved. Luckily, however, not every good photograph has to have a frame-filling bird in it, and you can get excellent shots of birds at greater distances.

I don't recommend anything less than a 200mm lens, for serious bird photography, and even this length will limit your activities somewhat. But a 200mm lens is lightweight, fairly compact, and easy to use. It's a popular size for sports photography, so there are lots of models to choose from. Most 200mm lenses have a maximum aperture of f/4 or even f/3.5 (an aperture you can live with), and the prices seem reasonable. These lenses can focus down to 6 or 8 feet and are very convenient for pictures of nests from an adjacent tree, for instance, or of the singing toad or butterfly you unexpectedly encounter.

A 300mm lens gives an image half again as large as a 200mm, but the lens itself is larger too and is seldom faster than f/5.6—meaning you must always use the next slower shutter speed.

In the past, long-focal-length lenses were large and cumbersome. Modern lenses are faster, and when used with a quality doubler, they become light, fast, and powerful. Here a 640mm Novoflex lens (top) is contrasted with a 300mm f/2.8 Canon lens that with a doubler becomes a 600mm f/5.6—less than half as long as the Novoflex and more than twice as fast.

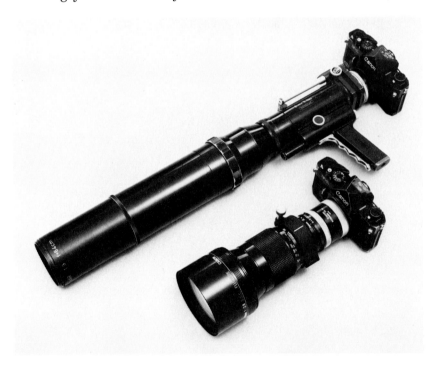

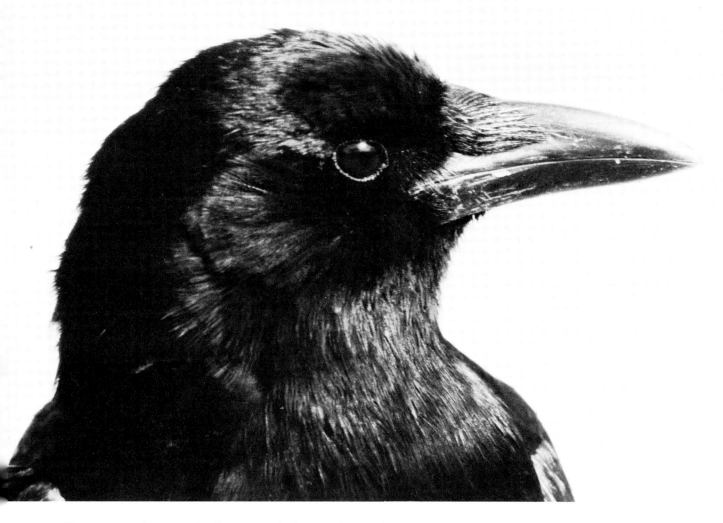

But 300mm is not a bad size, and if you plan to have only one long lens for bird photography, it might be the best choice. My first long lens was a 300mm, and I produced several thousand reproduction-quality pictures with it before I got anything longer. Certainly, if you bump into a really good buy on a 300mm lens, don't hesitate.

With a 400mm lens you really begin to get into the big time, and if you also have a good 200mm you can handle almost all the birds you are likely to meet. A 400mm is about the upper limit for hand-holding, but is the *lower* limit if you are stalking warblers and other small birds. The 400mm lenses are usually *f*/5.6 and are difficult to use if much slower. With a 400mm lens the normal microprism focusing screen works well, but longer lenses should be used with a viewfinder screen designed for long lenses. There are some "bargain" 400mm *f*/6.3 lenses advertised in the photography magazines and the Sunday newspapers, and one "bargain" 500mm *f*/8 as well. These lenses are very inexpensive and give surprisingly sharp images. I find them a trifle hard to focus and a little fragile, but they are an awful lot of fun to use. With care they should last a long time

Though it looks almost like a studio portrait, this picture of a wild crow was taken outdoors. The crow was attracted by tossing bits of bread and was then photographed with a 400mm lens from a distance of about ten feet.

23

and are a good low-cost way to start using long lenses.

The longer lenses—500mm, 600mm, and up—are really specialized tools. The image size gets bigger, but their weight, cost, and awkwardness grow as well. These lenses are seldom faster than ƒ/5.6, and often ƒ/8 or ƒ/11. With these slow maximum apertures you must use a tripod or other support. The main function of these extra-long lenses is stalking very shy and/or very small birds (or producing a huge sun image in pictures of sunsets). Very long lenses are great to have when you need them, but fortunately that isn't too often.

NORMAL AND WIDE-ANGLE LENSES

Most 35mm SLR cameras come with what is called a "normal" lens—something in the area of 50-55mm. These lenses can be very useful for photographing friends or scenic views, but they are just too short for most bird photography. To get a frame-filling photograph of an average-sized bird with a normal lens the camera would have to be within one or two feet of the bird, and most birds are not likely to let you get that close.

Lenses shorter than 50mm are called wide-angles because of their wide field of view. While these lenses have their uses, and unique optical properties, they have the same problem in bird photography that normal lenses do. The wider angle of view means that they also have a smaller image size, and consequently you must get even closer with a wide angle than with a normal lens to get a frame-filling picture.

However, normal and wide-angle lenses do have specialized uses in bird photography. They are useful for taking pictures of groups of birds—such as a flock of geese on a lake or a group of gulls circling overhead. They can also be used with remote-control cameras in situations where the camera is mounted close to a nest or feeder and you have retreated to a distance where you will not disturb the bird but can operate the camera.

An extreme wide-angle lens (17mm) is normally not used to photograph birds, but in this case it enabled the photographer to capture not only a common tern on her nest but also the nesting habitat, sky, horizon, and other terns. The remote-controlled camera was about sixteen inches away from the bird and nest.

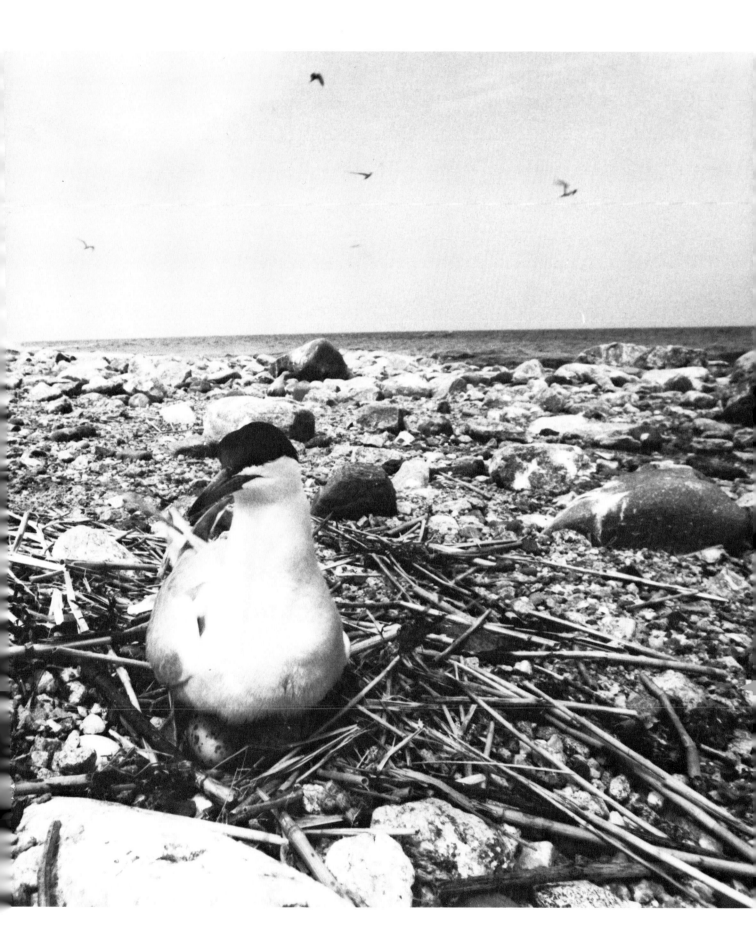

Optical doublers are valuable tools in any photographer's kit. With the addition of a small doubler, the 200mm Canon f/2.8 telephoto (top) becomes a very compact 400mm f/5.6 lens (bottom) that will focus to six feet—a useful tool. When using doublers with high-quality lenses, there is very little quality loss.

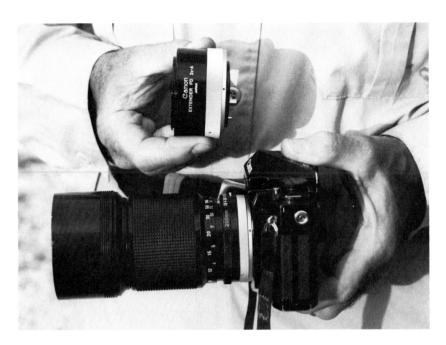

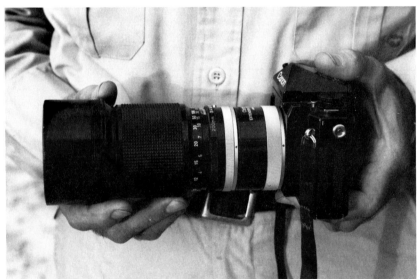

DOUBLERS

One way around the problem of never having a long enough lens is to use a doubler, also known as a tele-extender. Astronomers have used them for fifty years or more. They are attachments that double the effective focal length of the lens when placed between the primary lens and the camera body. However, they also cut down the light by 75 percent, or two full stops. An f/2.8 lens becomes an f/5.6 with a doubler, an f/4 becomes an f/8, an f/5.6 becomes an f/11, and so on.

Like lots of other things, some doublers are good and some are terrible. The 1.5X and the 2X ones can be great, but I've never used a 3X or "zoom" extender that was any better than awful. For the highest quality (and the highest price), get one

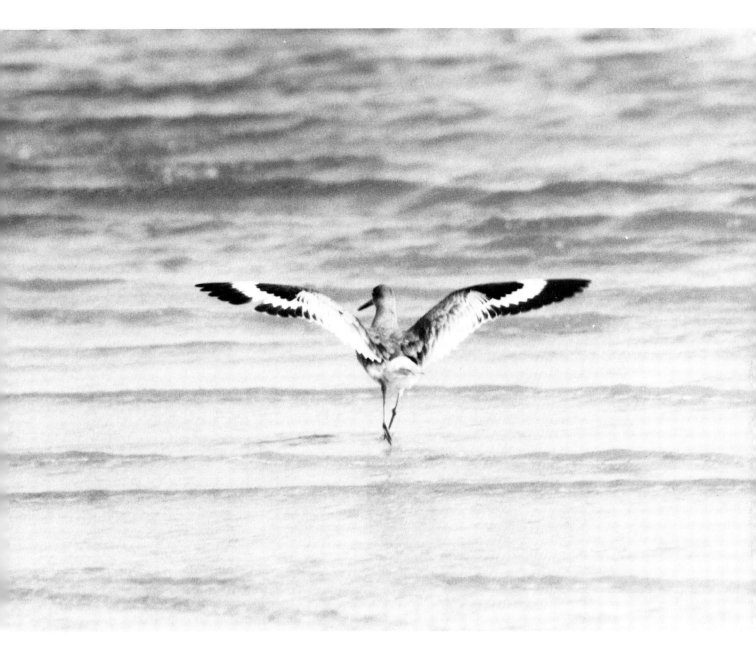

made by the manufacturer of the lens. Some independent manufacturers make decent doublers that cost much less. I have three of these that are surprisingly good for the price. Arrange to make some test shots, check the edges of the images you get and check for color and sharpness. You may well be happy with the results.

Another slight advantage to using short telephoto lenses with doublers is that the filters for the primary lens can also be used in the doubled mode. Most name-brand cameras have one filter size to fit as many different lenses as possible—52mm and 55mm are the most popular. With these systems any filter will fit lenses from 28mm to 200mm—as well as a 200mm when it's doubled to a 400mm.

The easier a telephoto lens is to hold and use, the better pictures you'll be able to get. This willet was flushed by walking toward it slowly and changing focus all the time. When the bird raised its wings to fly, the exposure was made, showing the distinctive wing pattern. This photograph would have been difficult or impossible with a heavy, clumsy lens.

27

ZOOM LENSES

The same general situation exists in the case of zoom lenses: there is a quality loss, and the images they produce may not be as sharp as those of fixed-focal-length lenses, but they are good enough that lots of people are happy with them. They certainly are convenient. However, you always have to consider the weight, bulk, and cost of the longest setting; a 70-210mm zoom is always as long, as heavy, and as expensive as a 210mm lens, if not more so. Zoom lenses are also apt to be slower than fixed-focal-length lenses.

Some zooms have a macro mode, permitting photography of very small objects. This can be an added bonus to a zoom lens, but as with most freebies, the quality isn't the greatest. If you ever use a true macro lens, you'll never be happy with the macro-zoom combination again. But it *is* a convenient feature to have. It will let you get detailed pictures of a netted bird, nest, chicks, or whatever tiny subjects you happen on unexpectedly, without your having to lug around any extra gear.

MIRROR LENSES

Other lenses worth discussing are catadioptic or mirror lenses. These, through a sort of optical folding, achieve long focal lengths in a physically short lens. They are usually slow, have a fixed *f*-stop, and produce weird out-of-focus images, such as bright little doughnuts from sparkle on water or a maze of jackstraws from brush piles. In some cases these images can be distracting, but that is not their biggest problem. Mirror lenses tend to flatten out and mute colors much more than I like. I freely admit, however, that a hand-holdable 700mm-plus lens is a most valuable tool for bird photography.

Catadioptric (or mirror) lenses have astonishing focal lengths in physically small lenses. The Celestron C-90 shown here has a focal length of 1000mm and a minimum aperture of f/11. Can you imagine trying to hold and focus a regular lens that's 1000mm long—just under forty inches? The air release shown being used greatly minimizes vibrations and lens-shake, always a problem with long lenses.

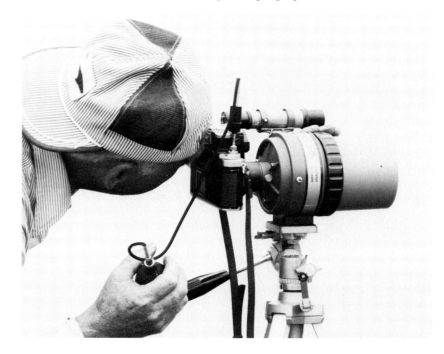

28

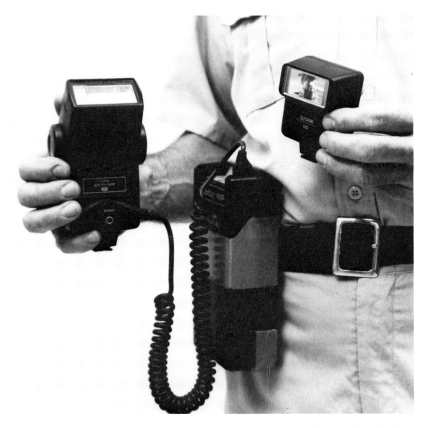

A pocket-sized flash unit, like the one on the right, is handy to carry "just in case," and good for closeups, where you want a weak flash. The other, medium-sized unit is more flexible in its uses and more powerful. The belt-mounted battery pack gives a thousand flashes and very short recycling times.

FLASH UNITS

Artificial light is a necessity at one time or another in bird photography. You can count on finding a nest in a shady spot, or a bird that likes to stay in dark places, and in these situations you will need some sort of additional light in order to get a properly exposed photograph. Floodlights are seldom used in wildlife photography, but flash bulbs and electronic flash units are commonplace.

Flash bulbs don't do much to stop action; they are one-shot affairs that cost perhaps a quarter apiece and must be accurately synchronized with the camera's shutter. They also put out a blast of heat and light that frightens many wild birds, so there are disadvantages. But flash bulbs also have their advantages: they are nearly foolproof, they work well in humid places where electronic gear may not, and they can be left for weeks or months, set and ready to go off, with no battery drain. Any sort of crude circuit, which can even be improvised from a flashlight, house current, or car battery, fires them.

Electronic flash units, often called "strobes," are generally more popular. They use an electric circuit to charge a capacitor, which is then discharged through a xenon-filled glass tube to produce rapid flashes of light. The original power may be house current or low- or high-voltage batteries. These units have good color balance and excellent action-stopping capabilities and can reveal things your own eyes can't detect. The extremely short burst of light (typically less than 1/1000 sec.) doesn't disturb wild creatures as much as a longer flash.

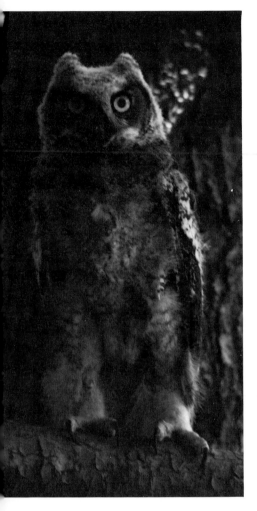 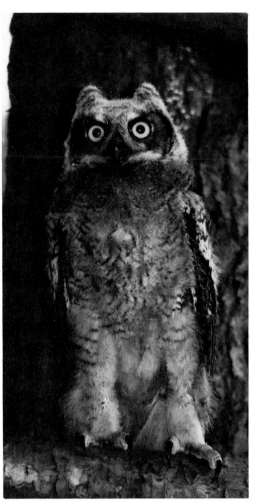 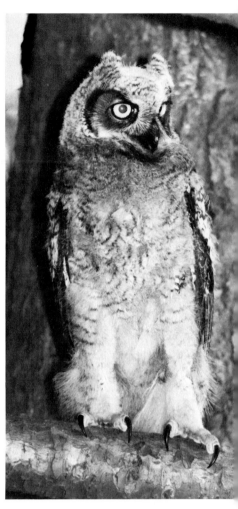

The picture of the young great-horned owl on the left was shot without flash, and may have a dark and menacing mood, but fails to show adequate detail. The one in the center was shot with a medium-sized flash, and shadows have been filled in, but much detail is still hidden. The picture on the right was shot with a powerful flash and reveals the entire bird, despite the dark woods.

Many flash units are available nowadays, and there are differences between them. Some types put out ten times the light of others and can be used with color film at 20 or 30 feet. Others are much weaker, but much more portable, and ideal for many situations. The duration of each flash unit differs, as does the recharging time. The choice of a unit depends on what sort of work you plan to do. If you know you will be using the flash only occasionally, at small distances, buy a smaller, cheaper, and weaker one; but if you will use it often and at long distances (or with a motor drive or at high speeds) it may be worthwhile to buy a bigger unit.

A newer, and very popular, type of electronic flash unit is the "automatic" exposure type. These units measure the amount of light reflected back from the subject during the operation of the flash itself, and they shut off automatically when there is enough light for proper exposure. These units are a boon to photographers who must work fast at different ranges, and the exposures are usually adequate for black-and-white and color-negative film. In my experience they are not accurate enough for critical color-slide photography, but almost all automatic units have a "manual" setting that bypasses the automatic fea-

ture, so these units can be used like any other for careful, accurate flash photography.

Most small units contain either disposable batteries or rechargeable nickel-cadmium low-voltage batteries. Either type works fine for bird photography, but the small units that use them usually take 5 to 10 seconds to recharge for another flash. When used with low-voltage batteries, many units hum, whine, or beep while charging, which may startle wild birds. However, most larger modern flash units have an accessory high-voltage power pack available (usually 300 to 500 volts). These high-voltage power packs offer very fast recycling, one second or even less, and they do not hum. They may also be left on for hours or days with little battery drain.

High-voltage batteries suffer in cold weather, however, and their output drops off markedly. Nickel-cadmium batteries work best in cold weather. Many units also have a plug-in adapter for use on regular 110-volt house current, a handy and economical feature for indoor work or at feeders near a building.

There are also some small accessories for flash shooting that you should own. First, extension sync cords enable you to move the flash off the camera and get some decent modeling in your pictures. While you are at it, get a spare cord; they are so fragile you will need another before long. If you use two or more flashes, get a slave tripper so that you can fire both at once without connecting wires.

MOTOR DRIVES AND POWER WINDERS

These are accessory devices which use a motor to automatically advance the film and cock the shutter of the camera after each exposure. They allow the photographer to take a more rapid series of photographs than is possible if the film is advanced manually. Because of this, motor drives and power winders are very popular for photographing fast action such as sports or a news event. They are also very useful when photographing birds in flight.

The motor drives currently available let you take anywhere from three to five frames-per-second (fps). Power winders shoot about two frames-per-second—and cost and weigh about half as much as motor drives. Which to get is up to you, but either one will give you lots more flexibility in shooting flying birds, as well as fill your wastebasket that much quicker.

I think it is a mistake to set a motor drive or power winder on "continuous," hold down the button, and let 'er rip. That way you are letting the *camera* decide the instant of exposure, and thus determine the picture. I prefer firing when the picture looks good and letting the motor rewind for the next shot.

A second advantage to using a motor drive or power winder for photographing birds comes when you operate the camera with a remote control. If you must advance the camera man-

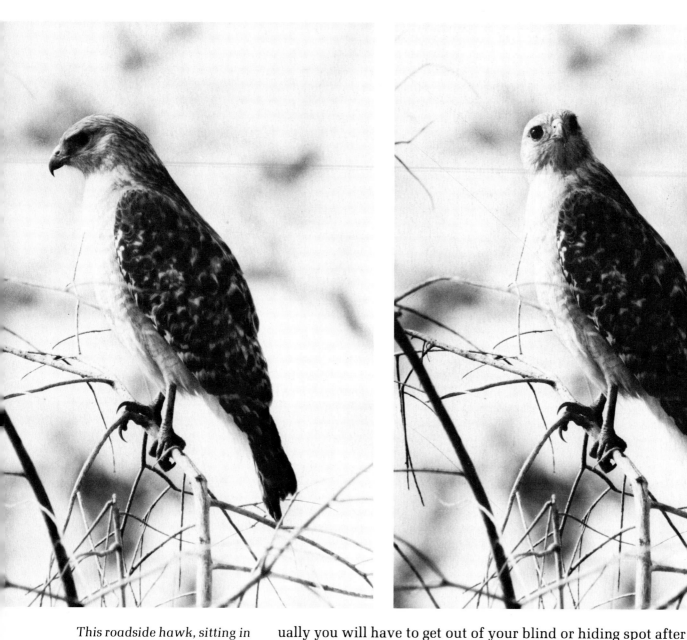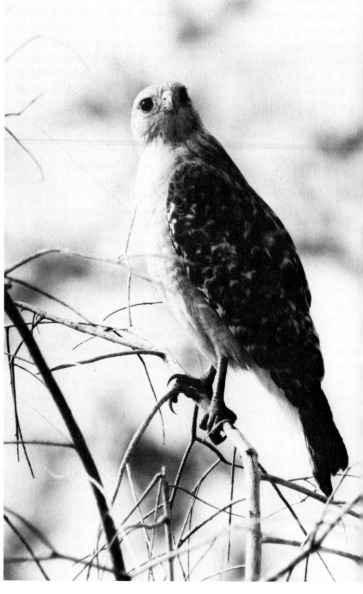

This roadside hawk, sitting in low shrubbery, was photographed from a car that had approached slowly. The first photo was taken with a 600mm lens at a range of about sixty feet. The sound of the motor-drive made the hawk look curiously toward the camera.

ually you will have to get out of your blind or hiding spot after each picture and walk up to the camera, probably scaring the bird away. Many motor drives also have a provision for being operated with either an electrical or radio remote control. With a motor drive you can remain at a distance, and photograph to your heart's content without disturbing the bird.

Motor drives and power winders are rather specialized (and expensive) pieces of equipment, but they can be a big bonus to the serious bird photographer.

FILTERS AND OTHER ACCESSORIES

Black-and-white photographers often carry a huge stack of filters—red, green, yellow, orange, and special—that color photographers don't need. The only filter normally used, or needed, by a color photographer is the polarizer. A polarizing filter is a

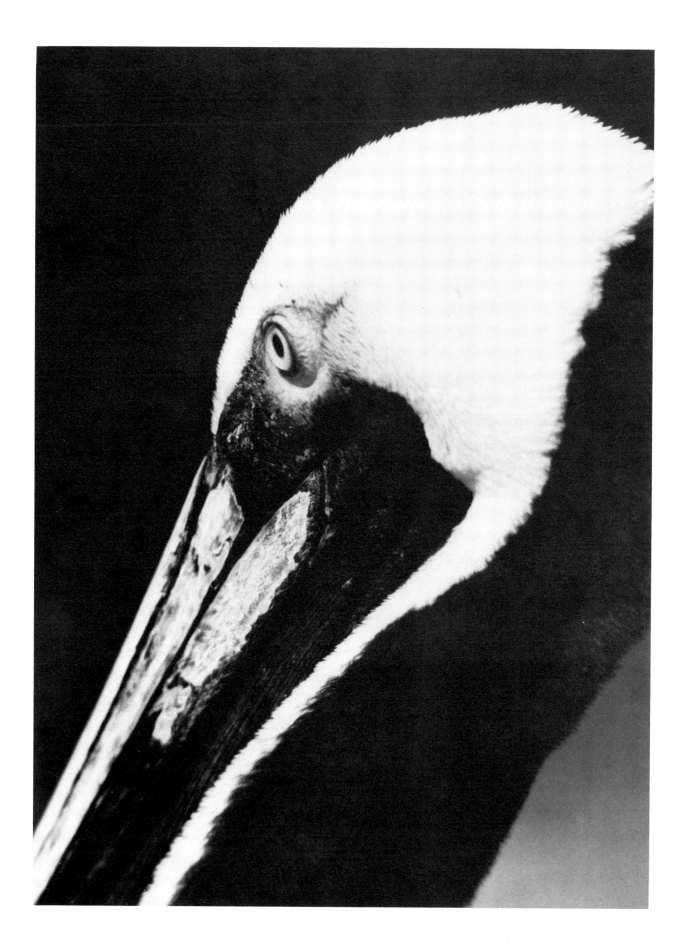

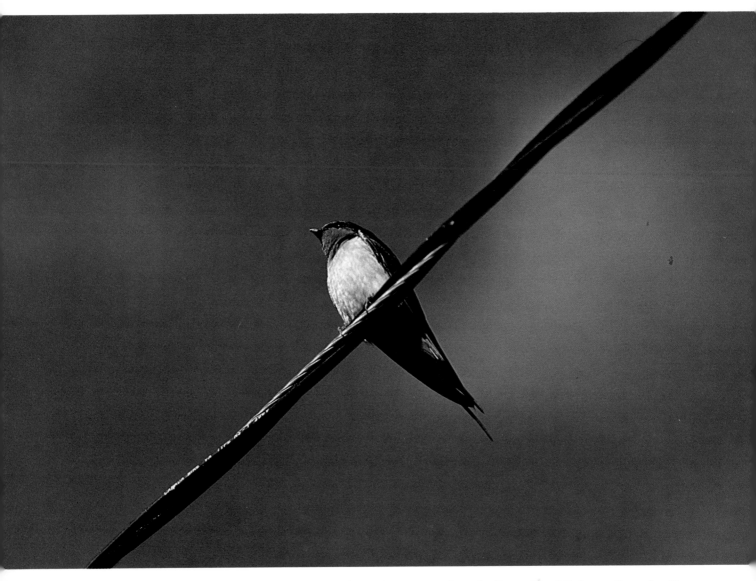

This barn swallow, sitting contentedly on a wire near a barn in British Columbia, was photographed from below with a 200mm lens. The swallow was used to seeing people and didn't feel threatened. A polarizing filter was used to darken and strengthen the sky.

variable filter that controls which angle of light strikes the film. I for one *always* have a polarizer along; so much can be done with it. Varying the color of the sky from "normal" to dark blue is the most common use, but you can also use a polarizer to eliminate water-surface reflections (to show a duck's foot, for instance) or to take the blue-sky sheen off shiny foliage. The polarizer also lets you slow down one more shutter speed when taking a blurred, slow-shutter pan shot. The polarizer is also handy to have for black-and-white film. It has about the same sky-darkening effect as a yellow or orange filter.

If you use your normal metering techniques with a polarizer, you may be in for an unpleasant surprise. Their polarizing effect can completely baffle certain built-in metering systems. Some cameras are worse than others, depending on where the designer put the meter's cells, but the only safe method is to take the exposure reading without the polarizer, then put it on, open the lens a stop and a third, and fire away. But first shoot

some tests to see if your camera has a serious enough problem to warrant this extra technique.

There are other filters, widely used in studio and movie photography, that warm or cool an image slightly—that is, make it more red or blue. These are seldom needed in field photography, though a blah sunset can often be zinged up by using an orange or red filter. What you should have for each field lens is a clear glass or skylight filter. Leave these filters on the lenses permanently, just in case salt spray, flying sand, a flying pebble, or whatever comes along. A chipped filter can be replaced easily and cheaply; a chipped lens is another matter entirely.

A good, neat and efficient way to keep all your filters together, clean, and dust-free is to use a metal screw-in (or screw-on) cap for each end and keep them in a stack. The male cap is simply a screw-in lens cap; the female cap is often called a stack cap.

Flying terns are a common sight, but by photographing them directly against the sun with a diffraction grating in front of the lens, all sorts of wild colors were created, lifting the picture out of the ordinary.

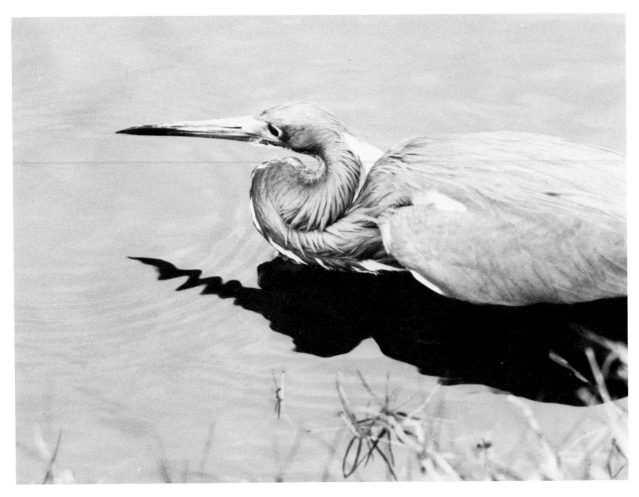

If a bird doesn't feel threatened, and perhaps is hungry as well, it may continue hunting or feeding while you ease up fairly close and begin to photograph. This tricolored heron was absorbed in its fishing and didn't mind the presence of the camera and 200mm lens about twenty feet away from it.

TRIPODS

If you hike a lot, or walk around for hours at a time, you may be tempted to select the lightest equipment you can find. This is fine for most types of equipment but with tripods it can lead to problems. A tripod is used to hold the camera steady, so steadiness should be the criterion for selecting one, not weight. Some ultralight tripods are so wobbly that they defeat the purpose of the device.

Another important aspect of the tripod is a central elevator post, which can come in handy for making minor adjustments of the camera's height. A tilt top that moves to let you shoot verticals is also an important feature. On the subject of legs, I prefer the lock-lever type over the screw-collar lock. Channel-leg construction seems to work better than the round-tube type.

Carrying a tripod can be uncomfortable no matter what type it is, but a small device called a clampod is simpler to carry and can function as well as a tripod in many cases. This device is a C-clamp attached to a tripod head, which can be clamped onto a branch, car door, fence post, chair, table, or whatever else is available.

Another good substitute for a tripod is something called a unipod. A unipod is a sort of adjustable-length walking stick

with a tripod head. It does steady the camera, but not as much as a tripod. One of the big advantages of a unipod is that it can be swung left or right, or forward or back, without much effort. A unipod can take a little getting used to, but it can come in very handy for photographing fast action (such as birds in flight) with long lenses.

CHANGING BAGS

It's always wise to be prepared for minor emergencies; one of the most frustrating is when the end of a roll of film tears loose from the spool. When this happens in the field, you have the choice of stopping shooting until you can get to a darkroom to remove the film safely, or opening the camera and throwing away the roll of film you've just finished shooting. There is one other option, however. You can carry a changing bag, a small bag with holes for your hands at one end and zippers at the other. It is designed to be light-tight when it is closed and your hands are inserted—a sort of portable darkroom. Just pop the camera inside, save the film for processing by putting it in a plastic film canister and taping it shut, and you are free to go right on shooting. It's a sensible item to carry on any kind of photography trip.

So how can you carry all this gear? Believe it or not, it can be done, and fairly comfortably too—but first forget the standard photographer's gadget bag; it's hopeless afield. Instead, haunt hiking, skiing, and biking shops and see what they've got. You might like a "fanny pouch," which straps around your waist,

CARRYING EQUIPMENT

A set of homemade belt pouches is very convenient for carrying photo gear while you hike. Made of vinyl, they fold flat when empty and take up very little room in a pack.

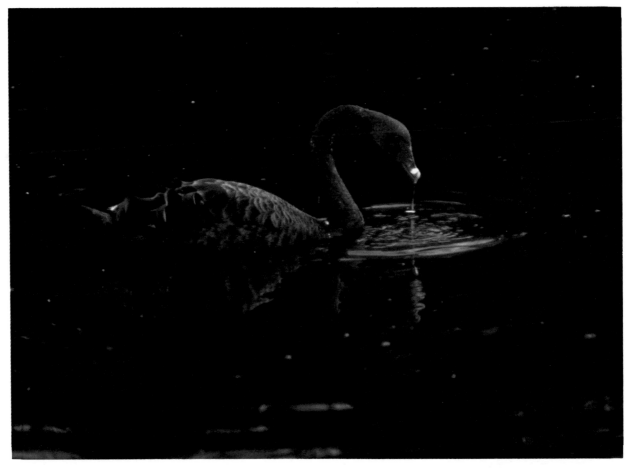

leaves both hands free, and holds buckets of gear. I use a big one that can hold two camera bodies, three lenses, twenty filters, ten rolls of film, and some knickknacks. This, coupled with a set of homemade belt pouches largely solves the problem.

Belt pouches for photography equipment are not available commercially but are simple to make. Measure your lenses, flash, and other equipment and lay out a design; be generous with the dimensions. Then stitch it up yourself, or have an auto-top shop or boat-cover maker sew the pouches out of vinyl material. Make a belt of the same fabric and use a two-piece buckle from a fabric store. You can also sew on little pockets to hold lens caps if you wish. Don't get overly neat and hem the edges of the pouches; they'll catch every time you remove a piece of equipment. Pinking shears make a good-looking job. These pouches can be folded flat when empty and take up almost no room; when they're full, you've got four items right at hand all the time (or three and a cold drink).

For traveling, there are some beautifully made waterproof aluminum cases that do a great job of protecting gear. They also do a great job of telling the world that they contain valuables. They're the first things to disappear at the airport or hotel. I prefer a large attaché case, which looks as though it contains nothing but papers and maybe a ham sandwich. Buy some blocks of

Above. *This exotic black swan was photographed with a 200mm lens.*

Right. *The striking markings of the saddle-billed stork are most startling when viewed head on. This shot was taken in Africa with a 200mm lens and Kodachrome film.*

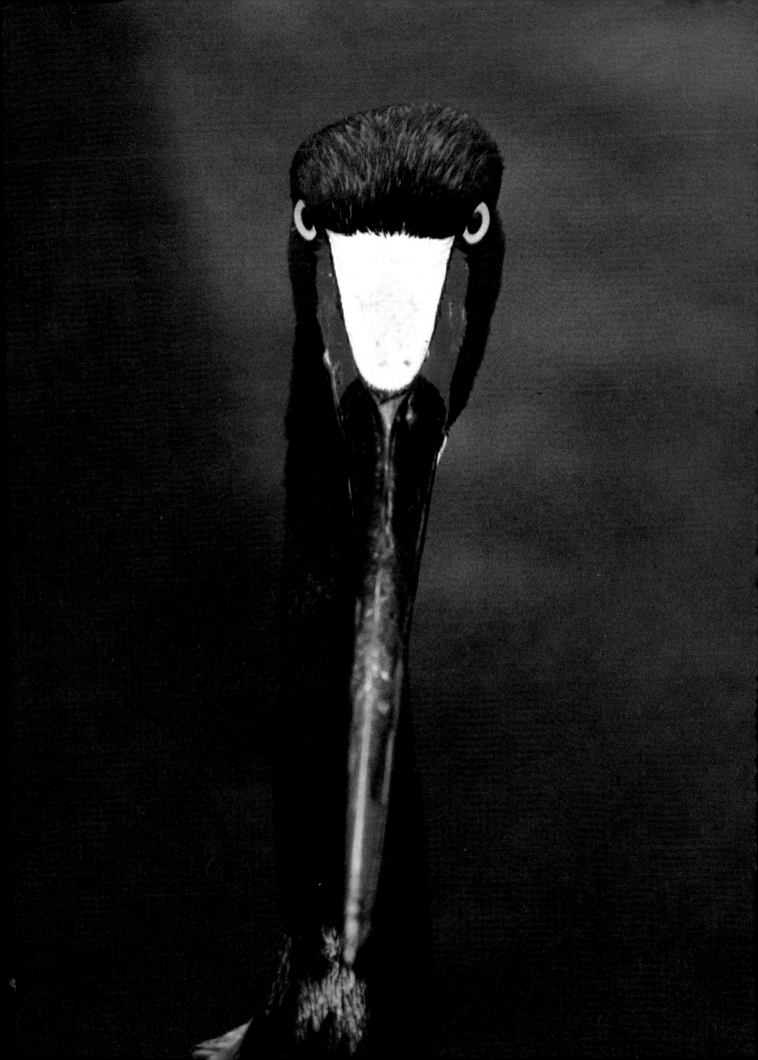

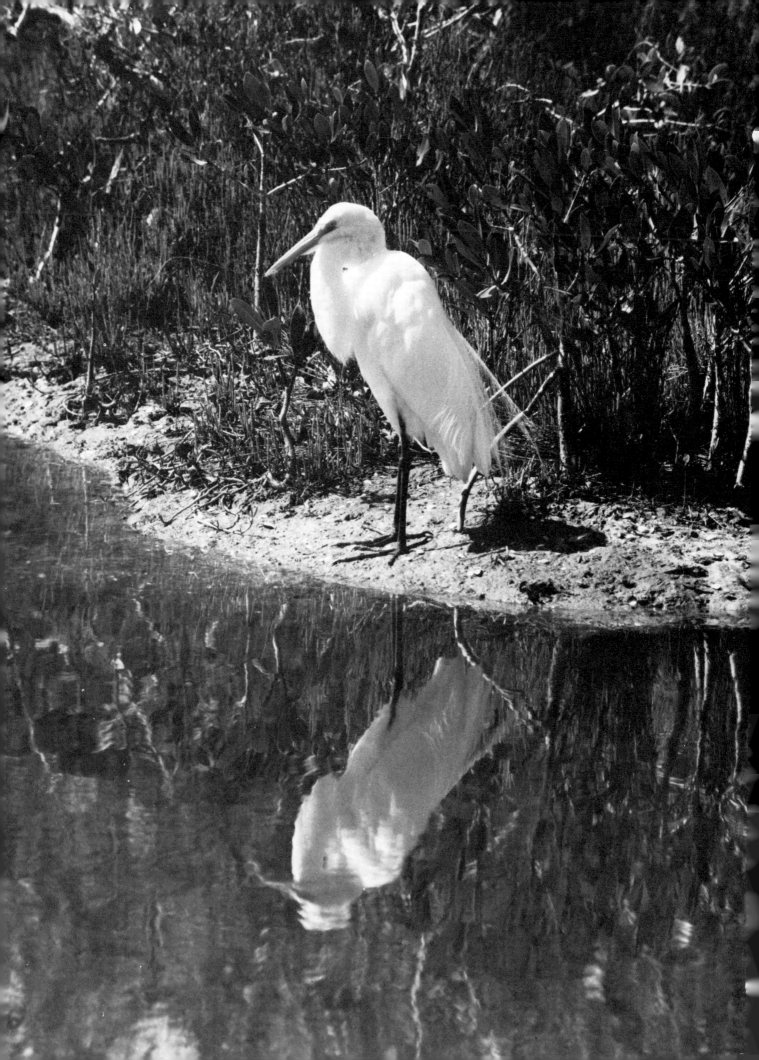

foam plastic, one piece thick enough to line the lid, the others the same thickness as the body of the case. Then with a sharp razor blade cut out holes the shape of your cameras and lenses. Put a thin piece of the cut-out foam in the bottom of each hole. Now your gear is well protected for traveling and not likely to disappear. My case holds three camera bodies, six lenses, and a small flash. Under the foam in the lid are two rolled-up foil reflectors, a cable release, spare meter batteries, model releases, customs forms, and a few other miscellaneous items.

When you don't want to carry a case, you can easily carry two cameras around your neck, one on a long strap and one on a short one, and shift them both to one shoulder or the other when your neck gets stiff. The stock straps that come with cameras are too narrow and get uncomfortable after a while. The gaudy "professional" straps (which I've never, ever seen a professional use) are too wide. The happy medium is a piece of nylon tape about three-quarters of an inch wide; simply sew it to a pair of "no-mar" rings from a photography store, and you're set and comfortable for years. Make the strap a convenient length and you won't have to bother with an adjustment buckle.

Lenses longer than 200mm ride best in an over-the-shoulder carrier like an archery quiver. Again, such a carrier must be homemade, or at least custom-made. It pays to make a rough one at first, try it out, change dimensions until it works well; then make a good one.

TAKING CARE OF EQUIPMENT

Perhaps even more important than carrying all your gear is taking good care of it. First should be an "all-risk, worldwide camera floater" from your insurance agent. Do this *before* losses or accidents, not after. Even if you have insurance, you must still take care of things. If you suspect rain, take along some plastic bags and a roll of masking tape. With a bag taped over the camera and all around the lens (and a skylight filter in place) you can keep on shooting in the rain, fog, or dust and nothing will be damaged. Moreover, if your camera does get a dunking, first remove and discard the film. If it was salt water, put the camera in a bucket of fresh water, open the back, take the lens off, cock and fire the shutter ten or twenty times, change the water, and do it all over again. If the camera was dunked in clean fresh water, you need only do this once. In either case *leave the camera and lens completely submerged* until you can get them to a repair shop. You can even mail a sealed plastic container of wa-

A common egret, sporting a few of the nuptial plumes for which the species used to be hunted, stands at ease on a mangrove flat. A vertical composition was chosen to include the bird's reflection.

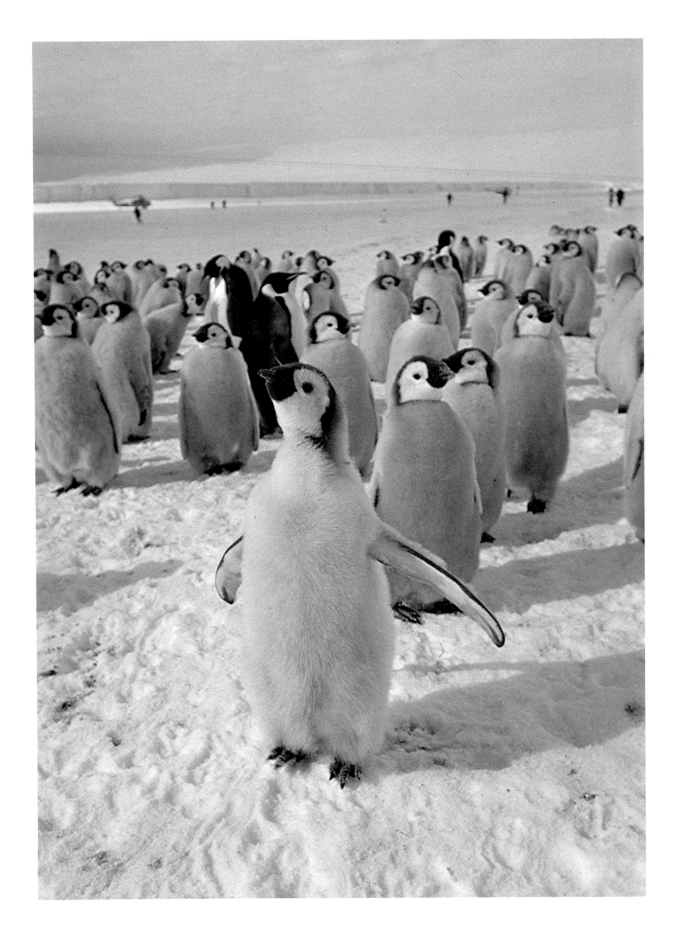

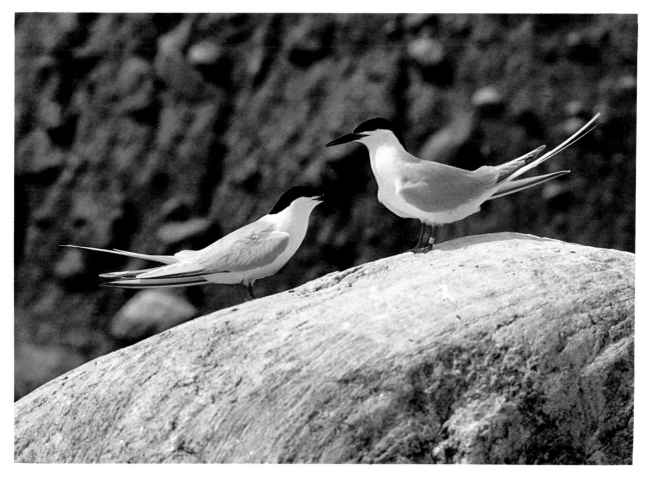

Above. *Both beautiful and graceful on the wing, roseate terns are also an attractive subject when perched on weather-beaten rocks. This pair was photographed from a blind near their nest.*

Left. *Before making the trip to photograph penguins in the wild, make sure all gear is in top condition. Temperatures are usually extreme, and repairmen in short supply.*

ter-and-camera—but don't let air get at it. Air rusts things; water doesn't. A repair shop should be able to salvage your gear.

Should you be in the boonies and a repair shop is more than a week away, you must make the repairs yourself. Flush the camera a couple of extra times, then take off every single piece that will come off, even the covers. (Don't lose those little screws!) Now put all the pieces, on a towel on a tray, into a gas oven, with only the pilot light burning, and leave them there for twenty-four hours. Every hour, or as often as you can, work the shutter, lens, and diaphragm mechanisms. Leave the shutter cocked one time, fired the next. If no gas oven is available, set the tray in the sun, protected from the wind, but don't apply any more heat than this. The lens may fog up and the shutter speeds may be off, but your gear will survive. A cleaning and lubrication when you get back home should make your camera (almost) as good as new.

It's a good idea to travel with a set of small jeweler's screwdrivers (handy for eyeglasses too), but almost all repairs should be left to the expert. One precaution you can take is to put a dab of shellac, or even clear fingernail polish, on the head of each screw on the camera, lenses, meters—everything—using a toothpick. This helps prevent the screws from loosening and dropping out.

Exposure meters are fairly fragile affairs, and they all fail occasionally. Be suspicious whenever you get a reading that is consistently different from what you would expect. When this happens, first check the meter against another camera or another meter. Then remove and clean both the battery and its contacts and any other electrical contacts. Then put in a fresh battery (you should always carry a spare in the field) and see if it makes any difference. If not, chances are that field repairs won't cure the problem. Run the meter's needle from one end of the scale to the other, by changing aperture and shutter speed. Also run the film-speed setting from one end of the scale to the other several times; this often wipes clean slightly dirty contacts.

If your camera's meter (or hand-held meter) is consistently high or low by a certain amount, you can change the film-speed setting on the camera until the meter gives correct readings under known conditions (like bright sun, which is 1/500 sec. at $f/5.6$ with ASA 64 film) and hope other readings are at least close.

Meters, like films, don't like the heat encountered in a car's glove compartment or on the rear-window shelf. They also don't like moisture, and they may become magnetized in some industrial situations; but they stand up surprisingly well. Before every long or important trip, however, check all your meters, built-in and otherwise. It's also a good idea occasionally to have the manufacturer or a camera store check your camera and meter.

SUGGESTED OUTFIT

I offer the following list of the equipment an avid bird photographer might amass, roughly in the order it should be acquired; it can of course be altered or shifted to suit personal preferences:

1. SLR camera and normal (50mm or 55mm) lens, economy model
2. 200mm lens with skylight filter
3. Fanny pouch
4. Lens doubler
5. Belt pouches
6. Clampod and tripod
7. Air release
8. Small flash unit
9. Bird blind
10. 35mm wide-angle lens
11. 400mm or longer lens; or trade up to a faster 200mm lens
12. Ultra-wide-angle (17mm to 21mm) lens
13. Shoulder stock (discussed in Chapter 4)
14. Second camera, body only, same brand but top-of-the-line
15. Motor drive or power winder
16. 100mm macro lens
17. 500mm to 750mm lens

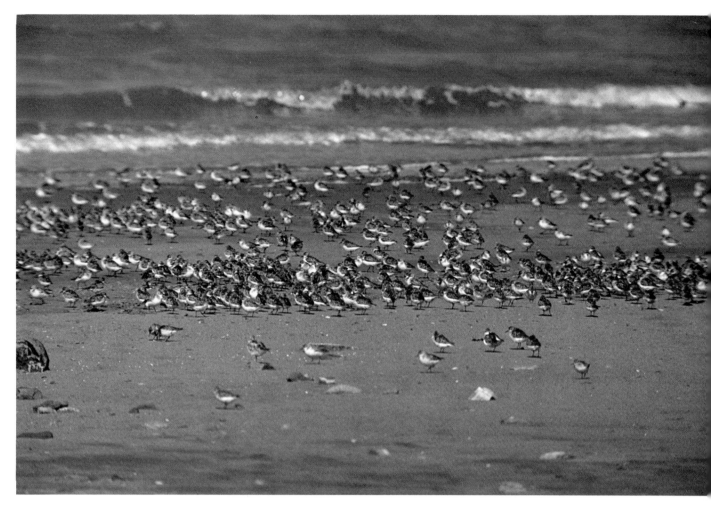

Above. *A group shot can be as interesting, and sometimes more representative, than a photograph of a single bird.*

Left. *Many birds, such as this American bittern, are colored so that they blend into their environments. This can cause problems for the photographer, but one solution is to follow the bird with the camera until it assumes a pose or reaches a spot where it stands out from the background.*

Remember to update your insurance policy as you add gear!

When you set out on a field trip, aside from the obvious photographic gear, it's a good idea to have any or all of these:

1. Small pair of vise-grips
2. Small changing bag
3. Plastic bags and masking tape
4. Jeweler's screwdrivers
5. Clear nail polish
6. Insect repellent
7. Audubon bird "squeaker"
8. Aluminum foil for light reflector
9. Small folding rain parka
10. Binoculars or spotting scope
11. Tripod or unipod
12. Band-Aids

The list can go on, *ad infinitum* if not *ad nauseam*, and there will always be things you need but don't have. But you'll be better off with the things on these lists than without them.

CHAPTER THREE
BASICS OF ALL PHOTOGRAPHY

Technically, photography is a mechanical-optical-electrical-mechanical process; and though a great many things can go wrong, in normal picture-taking situations few things ever do. Modern cameras are near-miracles of automation. The technical aspects of photography have been greatly simplified, and many of the risks and chances taken by earlier photographers have been eliminated.

No matter how "automatic" cameras have become, however, there are still many factors that are beyond the scope of electronics and microchips. Engineers have yet to come up with a camera that automatically fires the shutter in just the right place at the right time.

Good photography involves creative decision making. The person behind the camera must still choose the subject, the viewpoint, the angle, the instant of exposure—to say nothing of choosing the proper equipment to execute the desired photograph.

There are several factors that must be considered in all types of photography. Each of them crucially influences the final picture.

COMPOSITION

One of the most important factors in any type of photography is the composition of the picture. At its simplest, composition is the framing of the photograph—what you choose to include in the photograph, and what you choose to leave out. Obviously, a bird photograph won't work if it doesn't have a bird in it, but it might work better if it didn't have those telephone wires. When you shoot, you have to know what you want in the final photograph. Are you trying to get just the subject, or the subject and its environment?

Another element of composition is how the objects within the frame relate to one another. A slight change in the position or angle from which you take the photograph can totally change the appearance of the picture. You don't even need a camera to know that this is true. Cut a rectangular hole in the middle of a piece of cardboard and look at your living room through it. As you walk around the room, watch how the picture changes. The slightest movement causes the spatial relationships between the pieces of furniture to change. From one angle the couch might seem to dominate the room, but from a slightly different angle the same couch will seem crammed into a corner. In bird photography, a slightly different vantage point also can make an entirely different picture. In one shot the bird might appear dwarfed by the trunk of a tree, but in another the bird can seem much bigger than a branch of the same tree.

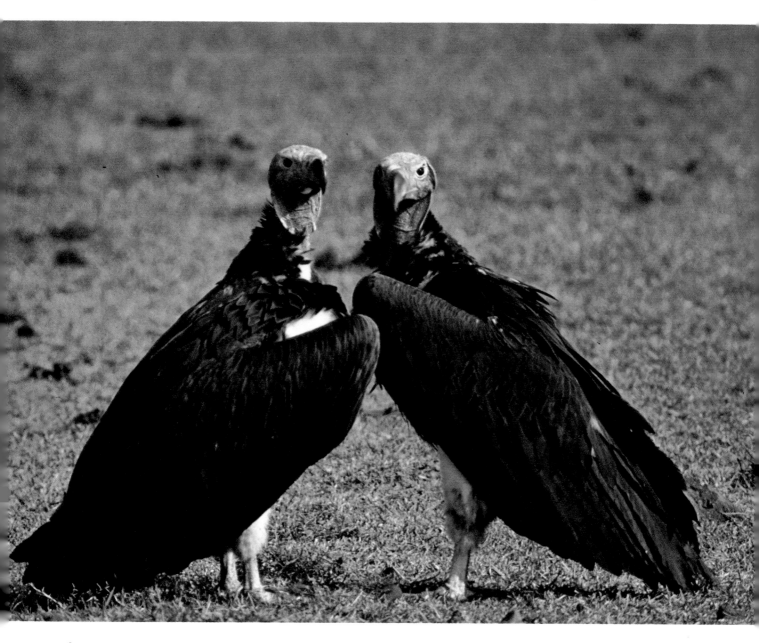

Above. Sometimes you can catch your subject in comical poses. These two lappett-faced vultures in Africa, for example, resemble a pair of bookends. The lappett-faced vulture is a huge bird, with a wingspan of over ten feet and a body length of forty inches.

Left. The chacalaca's name is unusual, as is the bird itself. The bird's soft colors register much better on color film in diffused light than in harsh, direct sunlight.

Sometimes, with a patient bird and a bit of luck, you can move around your subject to get pictures of varying compositions and different angles of light. The same pelican was shot alone and side-lighted and then front-lighted with a companion.

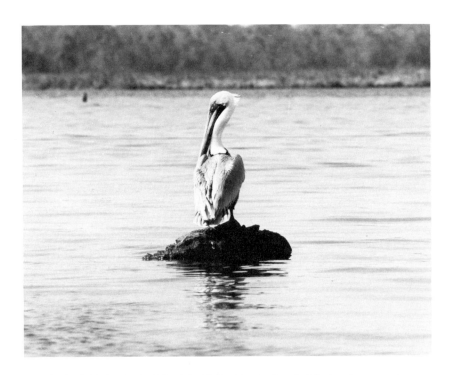

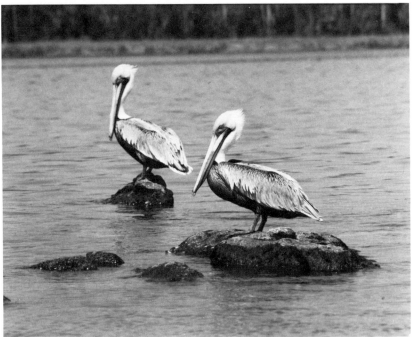

Composition is also the patterns and shapes the objects and colors of the picture make. People have written, and will continue to write, whole books on the subject, so I won't go into a detailed discussion here. Suffice it to say that you must be aware of how all these elements work. Practice, experiment, and think about composition. Take the picture you initially see, then move slightly and take another picture. You will soon discover what is dramatic and what is passive—what works for you.

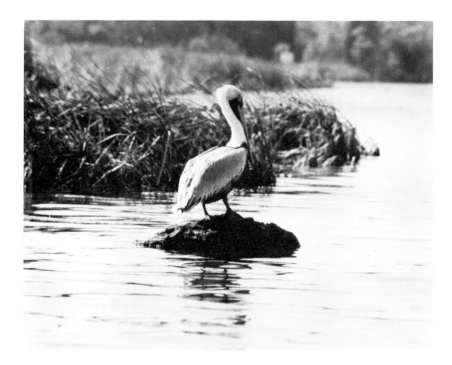

Moving around a subject lets you be selective about your background. By moving closer and using a shorter lens you can include more background; relatively less background will be included by backing away and using a longer lens.

DEPTH OF FIELD

Closely related to composition is the factor of depth of field. Depth of field is a physical property of photography that may be defined as the zone between the nearest and farthest objects in a photograph that are in acceptable focus. In almost every photograph not every element is in focus. The area in acceptable focus (as well as the point of focus) can be controlled. It can be very large or very small, and it can be placed in any part of the picture.

The depth of field of a photograph is controlled by several

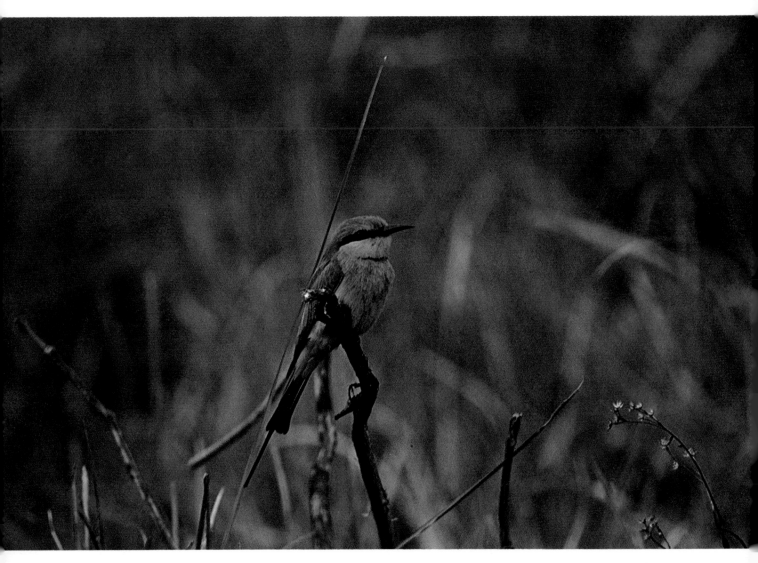

Using a wide aperture out-doors helps keep background elements from becoming dis-tracting, which can happen when they are in sharp focus. Here a green bee-eater is shown perched in the Kanha National Park in India.

things, including the aperture of the lens. The larger the lens opening, the smaller the depth of field; and the smaller the opening, the larger the depth of field. For example, if a 50mm lens is focused at 10 feet and the aperture of the lens is set on f/16, the depth of field will extend from 7 feet to 30 feet. At f/4, however, the depth of field will extend only from 9 feet to 21 feet.

There are many ways of determining what the depth of field will be. With most modern cameras the lens remains at its max-imum opening for viewing, but control called a depth-of-field preview. When this lever or button is moved, the lens stops down to the aperture opening set on it (at which the photograph will be taken) and actually shows the depth of field. Because the size of the aperture opening controls the amount of light en-tering the camera, however, the image in the viewfinder also darkens, sometimes to the point where you can't see anything at all, much less the area that is in focus.

Another way to check the depth of field provided by a partic-

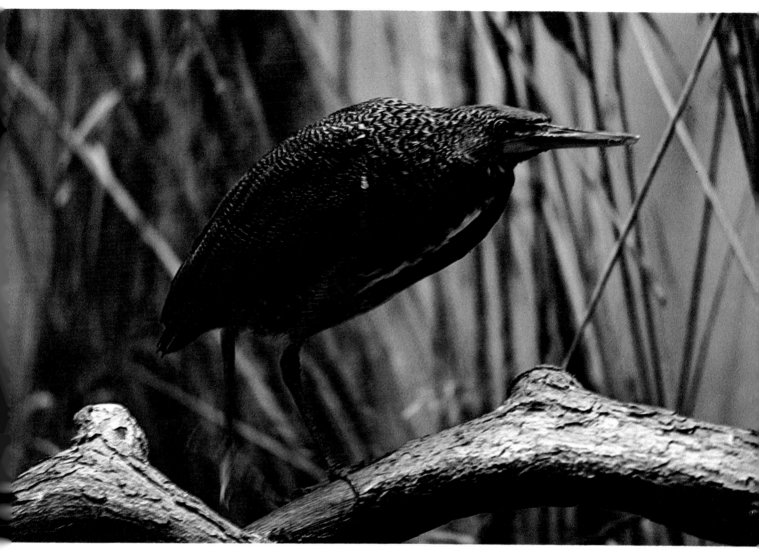

ular lens opening is to look at the top of the lens. Inscribed on it are a series of colored lines parallel to the index mark indicating the lens setting and the focusing distance. Pairs of these lines indicate the zone of acceptable sharpness for different aperture openings. When the lens is focused, the pairs align with different distance markings on the focusing ring to indicate the minimum and maximum limits of the depth of field at that particular aperture setting.

Other factors besides the size of the lens opening also influence the depth of field of a photograph. One of them is the distance at which you focus the lens. (The closer it is, the less the depth of field.) Another is the focal length of the lens you are using. (The longer the lens, the shorter the depth of field; and the shorter the lens, the longer the depth of field at the same opening and distance from the subject.)

As you look at more and more photographs—both good and bad—you will become conscious of how depth of field works with or against the photographer's intentions. In some photo-

Although the photographer usually has little flexibility of movement in a zoo situation, it is still possible to experiment with the camera-control variables. Using the widest possible aperture creates a shallow depth of field and helps isolate a bird from a background of the same general color.

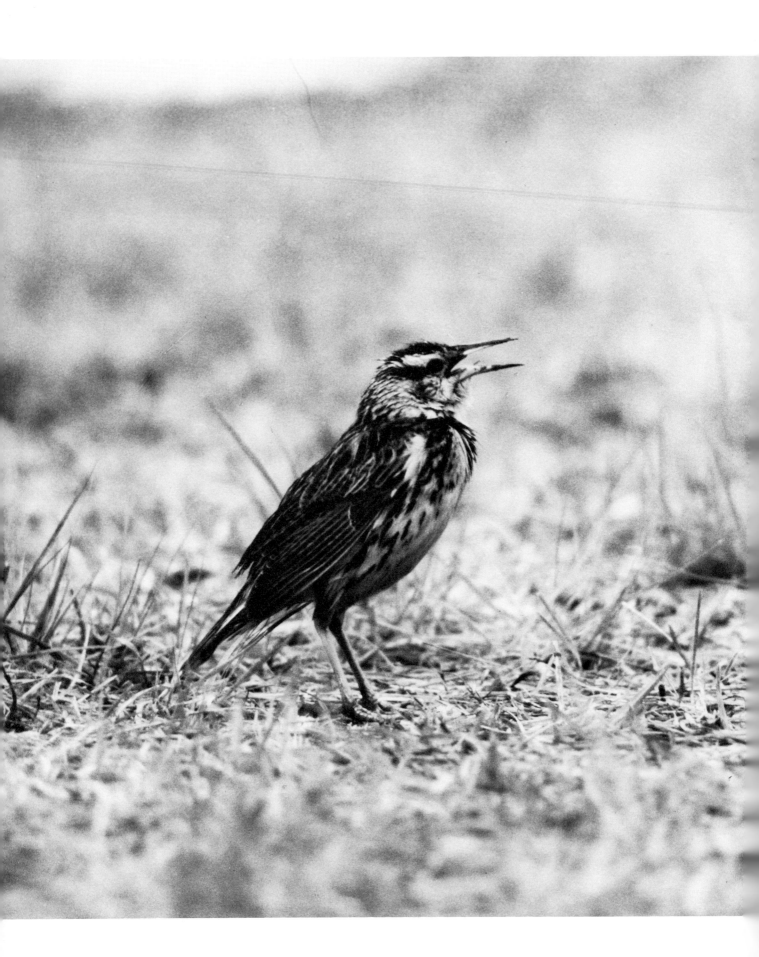

graphs a very shallow depth of field—with only the head of the bird, or even just the beak and the eye, in focus—is very effective. In another photograph a broad depth of field—with the bird, its nest or feeding ground, and the surrounding habitat all in focus—may be preferable.

EXPOSURE

Exposure is another of the critical elements of photography. Exposure refers to the amount of light that strikes the film inside the camera, and thus the lightness or darkness of the resultant photograph. A picture is said to be underexposed when it is too dark and it is hard to see any detail in the dark areas. Underexposure results from not enough light striking the film. An overexposed picture is one that is too light, that appears too washed out and weak in the light areas. A properly exposed photograph is one that shows the most detail in both the light and dark areas of the scene and that also has tones running the gamut from pure white to pure black.

Two controls on the camera regulate the amount of light entering the lens and striking the film. The first is the shutter-speed control. The longer the shutter stays open, the greater the amount of light that strikes the film. Shutter speeds are usually fractions of a second (though full-second speeds are also possible), and they are double or half the amount of the adjoining speed. Thus 1/30 sec. is double the amount of time and light of 1/60 sec. and half the amount of time and light of 1/15 sec.

The second control is the aperture, or size of the lens opening. The larger the opening, the more light is admitted in the same amount of time. The size of the aperture opening is denoted in f-stops on the lens, numbers like 2, 2.8, 4, 5.6, and so on. The numbers denoting the size of the opening are not exactly double or half the next number, but the amount of light these openings admit is. Thus, f/2.8 admits twice as much light as f/4 and half as much light as f/2.

Since both shutter speeds and apertures either double or halve the amount of light admitted, the same exposure is possible with several different settings. For example, 1/1000 sec. at f/4 admits the same amount of light as 1/500 sec. at f/5.6, or 1/60 sec. at f/11. Which of these settings you use is an important

Note that although the depth of field is shallow, this young meadowlark is centered in the plane of focus. When a long lens is used, accurate focus is critical. If the foreground and background of the picture had been sharp, the many blades of grass and twigs would have been distracting. A 600mm lens was used on a low unipod.

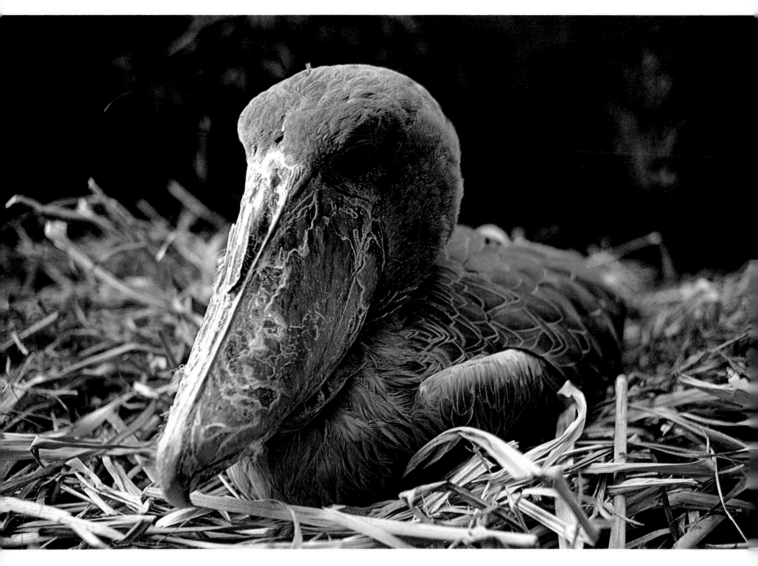

factor in finetuning your image. In some instances you will be more concerned about having a small aperture opening for increased depth of field, whereas in another picture you may want a fast shutter speed to stop the fast motion of a bird.

In practice, though, today's cameras are marvels of automation (perhaps too much so); they either set themselves altogether or simply require you to tweak a dial. Built-in meters are much better than they used to be, and you can usually trust them blindly. Some automatic cameras choose both shutter speed and lens aperture; you need only hit the button. Other camera have shutter priority—you set the shutter speed and the camera sets the aperture. Aperture-priority cameras do just the opposite. In manual cameras you change either the shutter speed or the aperture setting until two needles line up (or lights light). Almost all modern cameras have a "stop-down" mode to use with telescopes, "brand X" lenses, microscopes, and other auxiliaries.

The metering systems of most cameras are now "center-

Above. In dim light it is almost impossible to stop down the lens far enough to get everything in sharp focus and still have sufficient light for exposure. In such situations you may have to settle for a shallow depth of field and use it to the best advantage. Here, the shallow depth of field places emphasis on the shoebill stork's eye.

Right. To include the maximum amount of information a broad depth of field is preferable. In this photograph a wide depth of field and a wide-angle lens recorded many significant details of this booby colony.

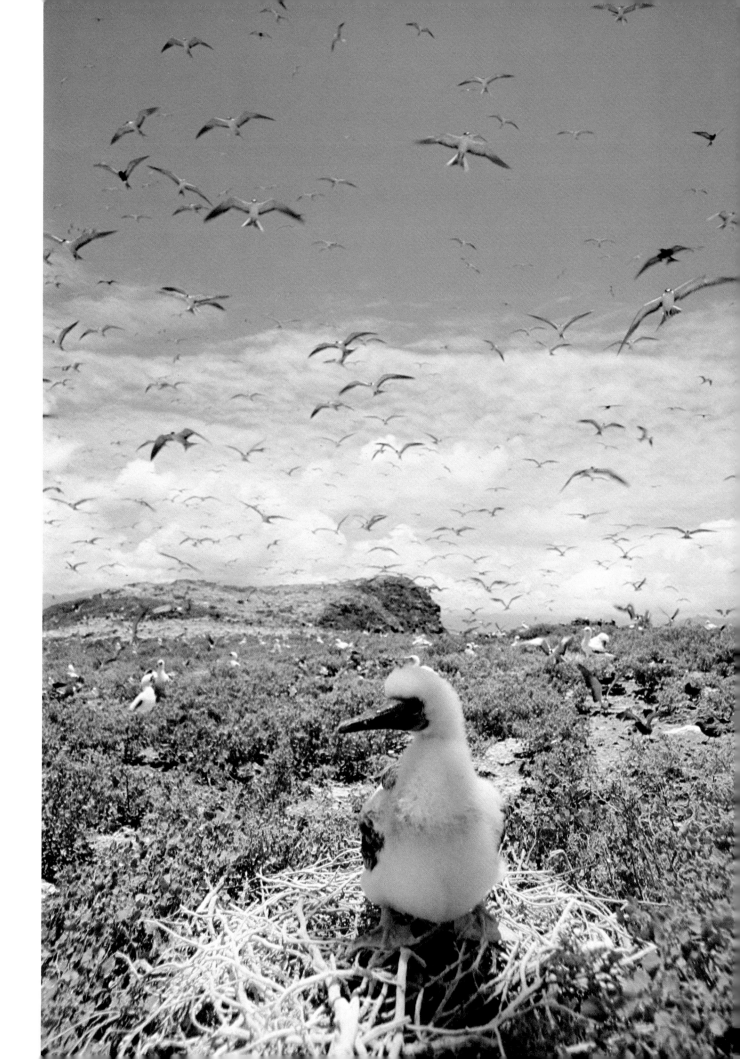

Above. *A white, "bald" sky behind a bird will fool an automatic camera meter and will result in the bird being underexposed. It is possible to compensate by setting the automatic camera on +1 or +1½ or by opening up an extra stop with a manual camera.*

Left. *Exposure is especially critical when there is a wide range of tones in the subject. A white bird against dark water ranges from pure white to pure black; the aim is to try and preserve as many of the middle tones as possible.*

weighted" or "bottom-weighted," meaning those areas of the picture affect the meter more than other areas. It's a good idea for snapshots, but you often have to compensate for it in serious work. If you take a vertical picture with a bottom-weighted camera, you will be measuring a huge piece of bright sky with what is normally the bottom of a horizontal picture, and you're likely to get an underexposed photograph. This is one reason I prefer to use a camera that has a rectangle in the viewfinder showing the exact area being metered. With this type of system you see *exactly* what you are, and are not, reading for exposure determination.

EXPOSURE COMPENSATION

The exposure problem is a basic one—no camera without a spot metering system can know what you consider important in the scene, nor will it average everything it sees. If you shoot a white man in a black tuxedo, or a black girl in a white dress, the camera reacts to the clothing, and the skin tones will be poorly exposed. In bird photography you may well run into the similar exposure situations of a light-colored bird against a dark green bush, or perched on a twig against a bright sky. But there is a

Above. *It is seldom, outside a zoo, that you will have a chance to take closeup pictures of a bird; but inside a zoo it's another story altogether. Captive birds will often let you approach very close, sometimes as little as a foot or two away. This provides the opportunity for "head shots" of exotic species and detail shots of markings.*

Right. *Although it may seem strange to find a Brazilian cardinal in Hawaii, its brilliant colors blend well with the indigenous plants and animals. This picture was shot on Ektachrome to emphasize the riotous colors, although the film's relatively high ASA and consequent grain resulted in a slight sacrifice in sharpness. The clear, clean air is also responsible for the brightness of the colors in the scene.*

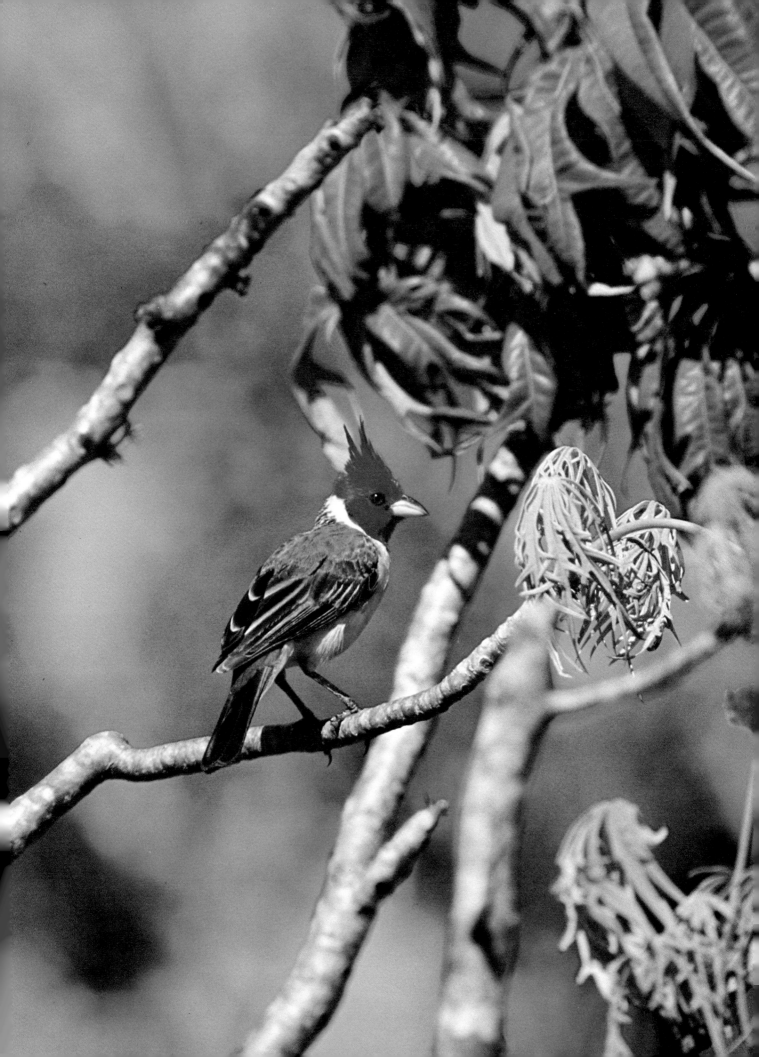

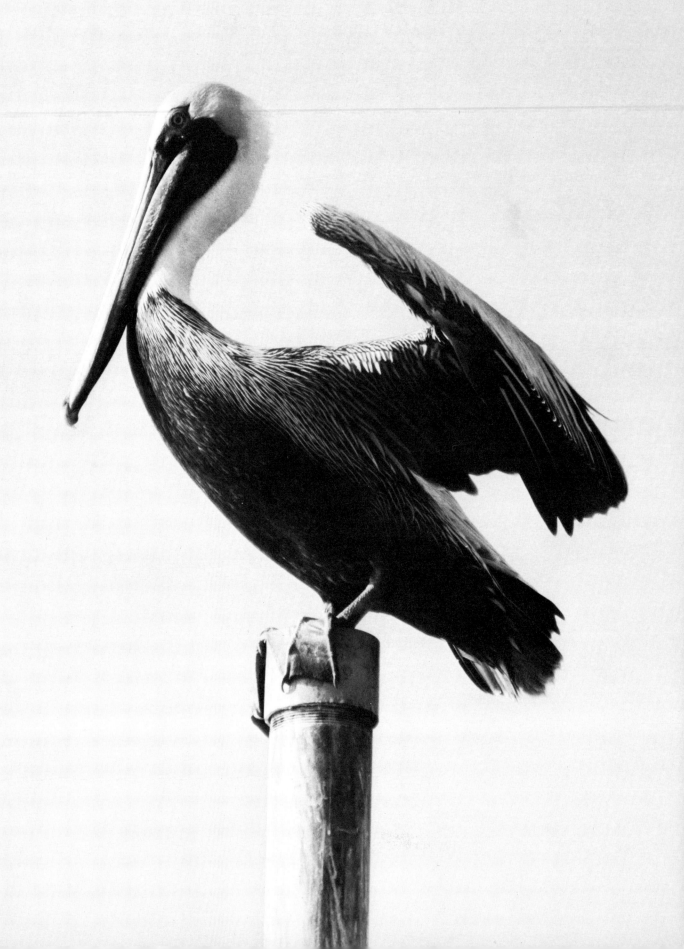

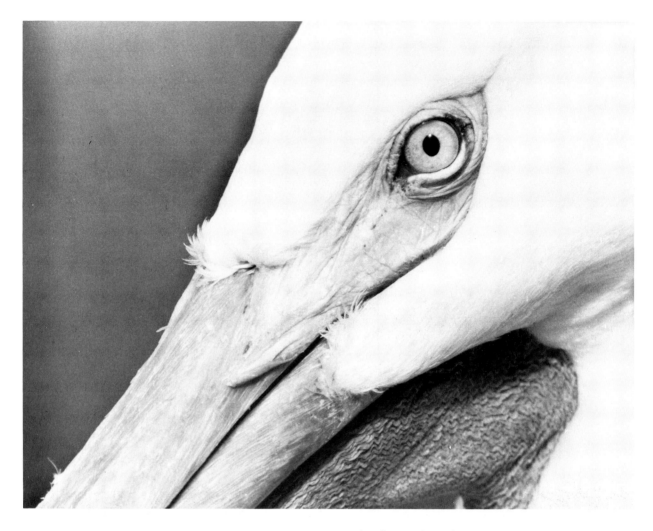

Above. *An eyeball-to-eyeball confrontation is startling, even if it is only in a picture. This white pelican was captive, shot from a few feet away with a close-focusing telephoto lens.*

Left. *Although this pelican seems to be fighting for balance (webbed feet weren't designed to perch on iron pipes), it is in fact raising its wings to take off. The photographer approached by boat and changed focus continually to keep the image sharp at all times.*

way to compensate in these situations.

If your subject is a dark object in front of a white (or light-colored) background (such as a bird sitting on a branch silhouetted against the sky), you should open the lens one or two stops to compensate for the camera's reading the light background. That way the bird (or dark object) will get enough exposure to show some detail. The opposite is true if the photograph is of a light bird in front of a dark bush. In this case the camera's meter will probably be dominated by the dark background, and you should close the lens down to expose the light bird properly.

Some "automatic exposure" cameras have a control designed to be used for exposure compensation; with other models it is much more complicated and involves changing the film-speed (ASA) setting.

You must be aware of such situations, learn what part of a picture your camera is metering, and learn to compensate when necessary.

There are also times when there isn't enough light on the subject to produce a good exposure. It is then that a small flash unit

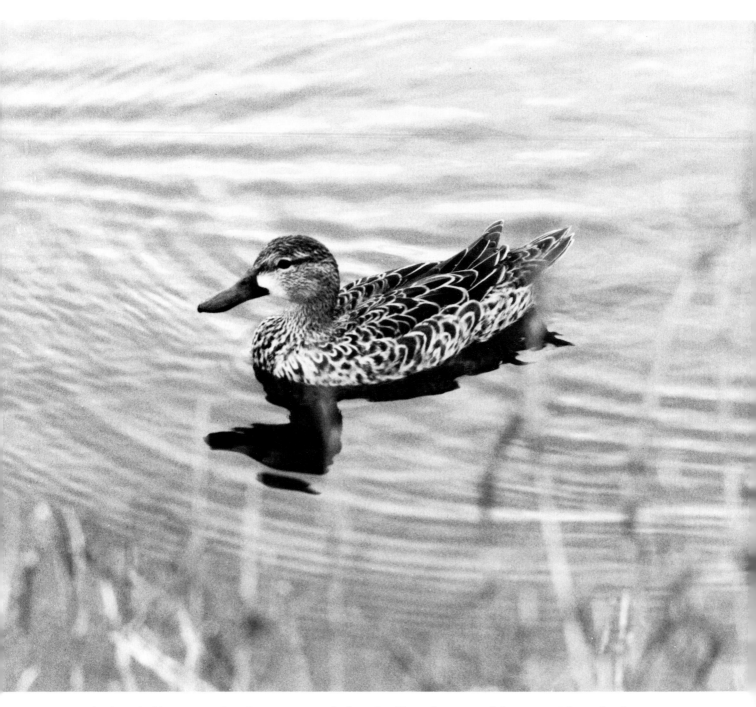

The female blue-winged teal may not be as striking as her mate, but she is still a good subject. This one was accustomed to seeing people and allowed the photographer to approach to a thirty-foot distance, close enough to use a 400mm lens.

comes in handy. For photographing a nest in a shady spot or a bird that skulks in dark places, adding light with a flash is the only answer. Modern units don't take up much room. Small units aren't very powerful (you may be able to shoot only at a range of 15 to 20 feet), but the capability to shoot at this distance is better than none at all.

On the subject of exposure, here's a bit of general advice. When you are shooting negative (print) films, either black-and-white or color, *over*expose if you are in doubt. With color-transparency (slide) films, *under*expose.

Things have progressed a long way in a few years when it comes to getting the sharpest possible image onto film. Higher-quality SLR cameras now have interchangeable focusing screens to allow the photographer to select one for the particular job at hand. Most less expensive cameras have a built-in focusing screen designed for all "normal" picture-taking situations. This screen, which you would use 95 percent of the time, usually consists of a microprism ring surrounding a central split-image rangefinder spot. The microprism ring causes an out-of-focus image to look like "heat waves," to appear to be broken up and waver as you move. As you focus, the image seems to snap into sharpness.

The central split-image spot allows you to focus exactly on any sharply defined object (such as a branch or a corner of a room). The spot consists of two semicircles that split the image into two parts. When the image is out of focus, the two halves of the spot appear to be out of alignment. When they are aligned, with no broken lines, the image is in focus.

This combination of central rangefinder spot and microprism collar is usually surrounded by a ground glass or Fresnel screen, which comes in very handy in low light and with wide-angle lenses. This outer field simply appears to be either sharp or fuzzy, in or out of focus. When the other focusing systems won't work, you should rely on the outer field—and your own eyes.

Any modern camera's focusing system will in all likelihood prove fully satisfactory; all it takes is practice. But, you should worry if you consistently get fuzzy pictures. If you have trouble getting sharp pictures and know you have taken the time to focus properly, try adding a plus-one diopter lens to the camera's eyepiece to sharpen the image. Almost all manufacturers make them available as accessories, and the increased magnification can make a lot of difference. You will be much happier with really sharp pictures.

Another of photography's fundamental decisions concerns the type of film you use. There are so many types presently available that the choice among them can seem confusing at first. Once you understand the differences between films, however, you can quickly narrow the selection.

FILM SPEEDS

One of the most important factors to consider when choosing a film is its sensitivity to light (commonly referred to as its speed). The sensitivity of a specific film is given on the box as its ASA (American Standards Association) or ISO (International Standards Organization) number. These two numbers are identical. The lower the ASA (or ISO) number, the less sensitive (slower) the film and the more light necessary to expose it prop-

FOCUSING

FILM

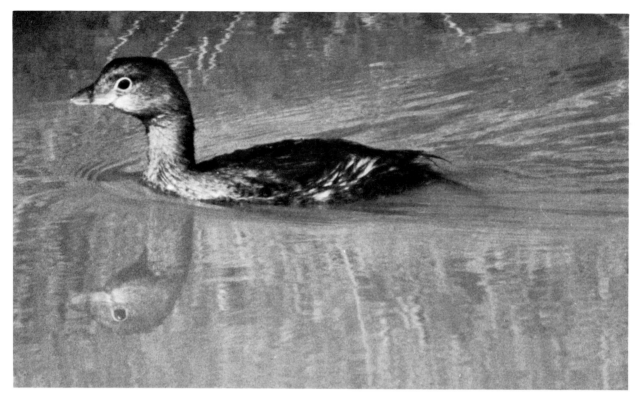

Small and fairly shy, the pied-billed grebe can be hard to get close to. If it is moving along a stream or canal, you can try getting into position ahead of it, preferably in a blind or a car and wait until the bird comes close enough for a photograph.

erly. The higher the number, the faster the film and the less light needed for proper exposure.

Under identical lighting situations, faster films enable you to photograph at faster shutter speeds to stop action and/or at smaller lens openings for increased depth of field. For this reason you might think you should always use the fastest film available, but that isn't necessarily so. Faster films generally produce lower-quality results than slower films, and the choice of film must almost always be a compromise between quality and practicality. About the only time it is not a compromise is when you have a subject that will hold still for a slow shutter speed and don't need to close down the lens to get more depth of field.

In normal practice, however, the choice among films need not be much of a compromise. Today's slow films (ASA 25-200) are fast enough for most outdoor photographic situations, and you need to use faster films (ASA 200-400) only for shooting indoors, at the theater, or for predawn or postsunset situations. Even in these circumstances you can use slower films if you add light with a flash or floodlights.

BLACK-AND-WHITE VERSUS COLOR FILM
Another distinction between films is the choice between black-and-white and color film. Each type has its advantages and disadvantages, but ultimately the decision depends on what kind of photograph you want to take—one in color or one in black-and-white. I prefer to photograph birds on color film—after all,

color is one of their most striking features—but I also do a lot of work in black-and-white.

COLOR-SLIDE VERSUS COLOR-PRINT FILM

There are two types of color film: color-negative (or "print") film and color-positive (or "slide") film. Again, the choice comes down to what you want the final picture to be. If you know you'll want prints—as of a baby picture to be mailed to twenty-seven relatives—by all means use color-print film. If you want slides—to illustrate a lecture, for example—use color-slide film.

The choice between prints and slides is not as cut and dried as it is between black-and-white and color film. You can have slides made from print-film negatives, and you can have prints made from original color slides. The problem is quality. Slides made from print films really aren't very good. If you suspect that you will want both prints and slides, use slide film. The best-quality prints are made from slides, but they cost more. I use slide film; that way I can get both high-quality slides and prints, but I pay more for my prints than I would if I used print film. It is a personal choice, and the bottom line is what type of film you like. Shoot a roll of both types, and see which satisfies you.

COLOR-SLIDE FILMS

When it comes to slide films, every active photographer seems to have a favorite that he or she swears by. In most cases, my own included, this is Kodachrome. Kodachrome is commonly held to be the sharpest film available, and it also gives extremely bright color rendition. With a good lens you can turn out Kodachrome slides capable of being enlarged to 2 by 3 feet with little loss of quality. In fact, billboards 40 feet long have been made from 35mm Kodachrome slides. To make this type of enlargement, everything must be right: the lens the best available, the camera rock-steady, and the exposure right on the button. But even then, the only film that could possibly hold such magnification without breaking up is Kodachrome.

There are two types of Kodachrome, one with a speed of ASA 25 and the other with a speed of ASA 64. Here lies the exception to the rule of using the slowest film available. I feel Kodachrome 64 has a slight edge over Kodachrome 25. There's not much difference, but I still prefer KR, ASA 64 Kodachrome. Others whose opinions I respect like KM, ASA 25 Kodachrome better. There's no way I can tell you which you'd prefer, so I suggest you buy a roll of each and shoot the ASA 25 roll first. When you finish that roll, stand right where you are, put in the other roll, and shoot the same subject with the ASA 64 roll. The subject, lighting, and everything else should be identical, but don't forget to change the exposure setting. This way the film will be the only variable. Mark the slides when they come back,

before they get mixed up, and you can compare the two films at leisure to see which one you prefer.

Other color-slide films show less sharpness and more grain but may have other advantages, such as more saturated—"jazzier"—colors.

Ektachrome is one of the most popular films. One of its advantages is that it can be processed at home if you want to play, but probably its biggest advantage for 35mm camera owners is its faster speeds: 160 ASA, 200 ASA, and 400 ASA.

It is also possible to boost the speed of Ektachrome by 100 percent—a full f-stop—in processing. Private processing labs do this regularly (and can also lower the film speed if you wish). Kodak offers an "ESP" service to double the speed of Ektachrome in processing. You have to pay a slight surcharge, and you will get more contrast in your slides, but it does work. Push processing can be a lifesaver if you've shot some great pictures in some not-so-great light, or if you forgot to change camera settings when changing from a faster to a slower film.

A few years ago I photographed the penguins indoors at the New York Zoological Park. To do it, I lugged in a camera, telephoto lenses, tripod, two strobe units, two light stands, 40 feet of wire, and a large black cardboard reflection eliminator. It took a couple of hours to set up and get the coverage I was after. Recently I shot the same birds again on high-speed Ektachrome (ASA 400), using the available light and shooting at 1/60 sec. at f/2.5. The only equipment I had was a 35mm camera and lenses. The results were good enough to be published in *Popular Photography* and required perhaps a tenth of the previous effort to produce. High-speed film certainly can come in handy.

BLACK-AND-WHITE FILMS

As for black-and-white films, I seem to end up using lots of different types, generally choosing each for the job at hand. I like Ilford films, and the specialized ones from Adox and Agfa, but I standardize on Kodak's Panatomic-X, rated at ASA 64 or ASA 125 (depending on subject and lighting). It's a thin-emulsion film with good acutance, a good antihalation backing, and great contrast. (That means I can make excellent 16 x 20-inch prints all day long.) It is fast enough for nearly all outdoor shooting and for much indoor work as well. When I need more speed, I jump to Kodak Tri-X (ASA 400). Many other photographers, especially press photographers, like Plus-X, a thick-emulsion film which I find lacking in edge sharpness; but they love it and get good results. Personal testing is the only way to pick your own favorites, so go ahead and try different types.

Picking one type of film and shooting lots of it lets you get to know what that film will and won't do, what you can and can't do with it. There's an old saying: "Beware of the man with only one rifle; he probably knows how to use it." Knowing how to use and get the most out of one good type of film puts you in the same category.

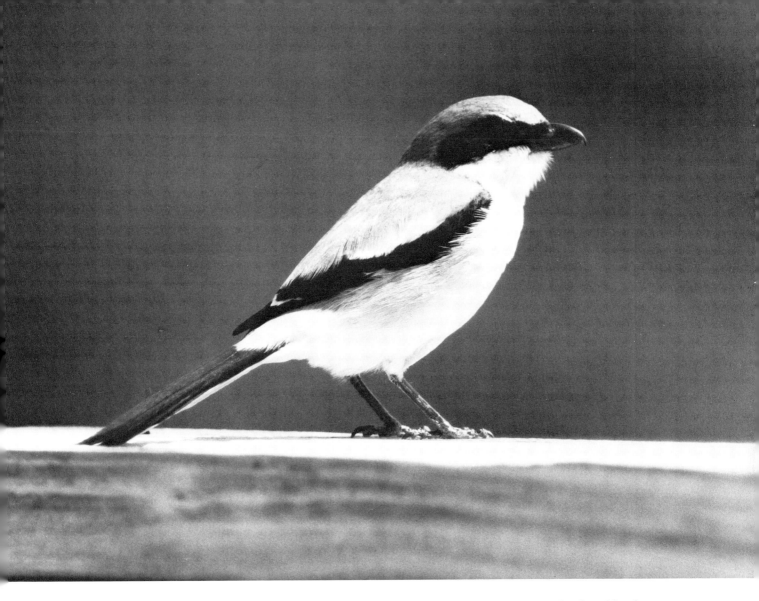

LOADING FILM

People always seem to run into trouble loading the camera with film. I don't know a single photographer, myself included, who has not wasted a whole roll of film because it was not threaded properly and did not move through the camera. All 36 exposures were made on the leader! This is preventable, but the proper way to load film is never given enough emphasis.

The proper process is simple. First put the film cartridge into the camera and insert the film leader into a slot of the takeup spool. Then lift the rewind crank out of the knob, and turn the crank gently in the direction of the arrow until the slack in the film is taken up and the film lies flat. Leave the rewind handle up and run your finger across the sprocket gear to make sure that a gear tooth is sticking through a sprocket hole on the film. Close the camera back, be sure it's latched, and crank off two exposures, while making sure the rewind crank is turning as you wind the film. If it is not turning, the film is not moving through the camera, and you must open the camera back and start over again. Once in a while the film will have some spring to it, and you'll have to wind the slack out again, or even hold the crank as you wind the lever. If you make loading this way a habit, you'll be happier.

Black-and-white film, because of its greater tonal sensitivity, often is more faithful in reproducing the subtle gradations we actually see. Here, a loggerhead shrike, a bird that is distinguished by its charcoal-hued feathers, is accurately recorded with a 600mm lens and black-and-white film.

CHAPTER FOUR
PHOTOGRAPHING BIRDS IN FLIGHT

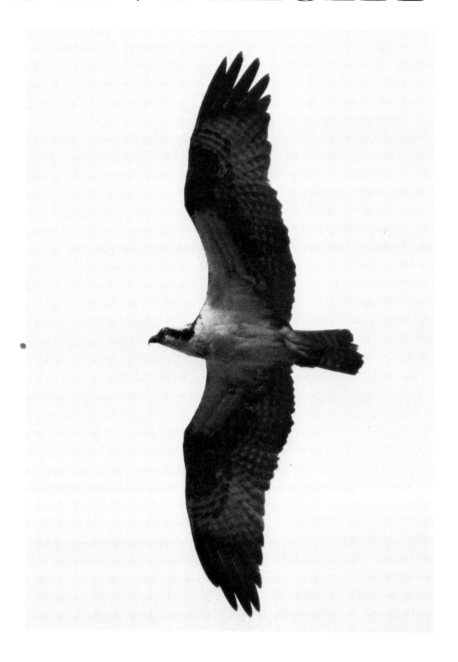

The big difference between photographing birds as they perch and birds as they fly (wingshooting) is the time element. The flying bird moves rapidly, forcing you to do all your focusing, framing, and composition under the pressure of the split-second clock. But this challenge can be met, and the results can be spectacular. What sets birds apart, after all, is their ability to fly—what better way to photograph them than in the process of flying?

The basic equipment is a telephoto lens in the 200mm range, though you may on occasion use a standard lens, or even a wide-angle lens, for groups of birds. A 200mm lens is fast enough to give you a bright viewfinder image and a high shutter speed, and it is lightweight enough and small enough to track a flying bird quickly. Though this lens is entirely too long for small darting birds and entirely too short for a soaring condor a quarter of a mile away, it's a good compromise for the birds in between.

There are lucky souls who can pick up a 300mm or 400mm lens and go right out and wingshoot with no trouble at all. There are also people who win lotteries. However, most of us cannot use a long telephoto lens without a lot of practice, and a 200mm lens is a good focal length to start with. As mentioned in the section on lenses, 300mm and 400mm lenses are seldom faster than $f/5.6$. The image in the viewfinder is correspondingly dimmer and harder to focus than the image with a 200mm $f/3.5$. An $f/5.6$ aperture, instead of $f/3.5$ or $f/4$ also means the photographer must shoot at one slower shutter speed. However, $f/5.6$ is still fast enough for a 1/500 sec. shutter speed, even with Kodachrome 64, in good light. I prefer to shoot at 1/250 sec. and $f/8$ under those conditions, as the smaller aperture gives a little leeway in focusing because of the greater depth of field. A shutter speed of 1/250 sec. is still fast enough to stop the wingbeat of larger birds.

PANNING

A technique known as panning is useful for photographing birds in flight. Panning involves following the subject to keep it in the same position in the viewfinder while snapping the shutter. If you're lucky, the technique causes the bird to be in focus and the background to be a blurred mass, emphasizing the bird's motion. The secret is to use a slow shutter speed and make your swing smooth and even.

A lot of the challenge of wingshooting has to do with the bird and the situation. Soaring birds, or at least those that soar occasionally—vultures, pelicans, hawks, and gulls—are relatively easy. If you are moving and the bird is soaring in the same di-

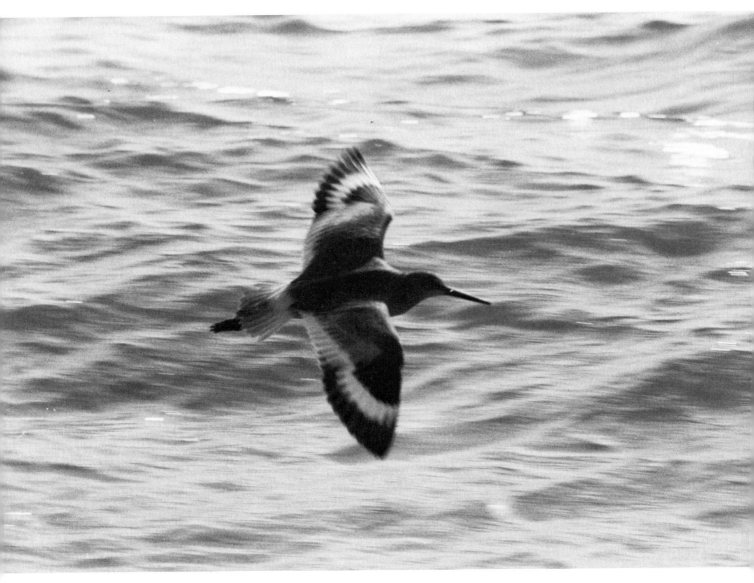

Panning with a fairly slow shutter speed and a 200mm lens yielded a good picture of a willet that shows the distinctive wing pattern and isolates the bird from its background. Since both the wave crests and the camera's motion were in the horizontal plane, the background blurring was less pronounced than might be expected.

rection—a gull by a ferryboat, for example—wingshooting is child's play. In relation to you and your camera the bird may not be moving at all. You have all the time in the world to line things up, focus, and hit the trigger—well, several seconds anyway. This is wingshooting at its easiest. You can even use a wide-angle lens.

USING SHOULDERSTOCKS

The shoulderstock is a basic accessory for the photography of flying birds. It is purely and simply a brace that steadies the camera against the photographer's shoulder and provides a firm support. It is usually used with a cable-release trigger or microswitch hooked to the camera's motor drive. Wooden shoulderstocks are simple to build out of a 1 x 6 x 14-inch plank. Cut it out to resemble a gunstock, and bore a cable-release hole where your index finger falls and another hole for a tripod screw with which to mount the camera firmly to the stock. You might

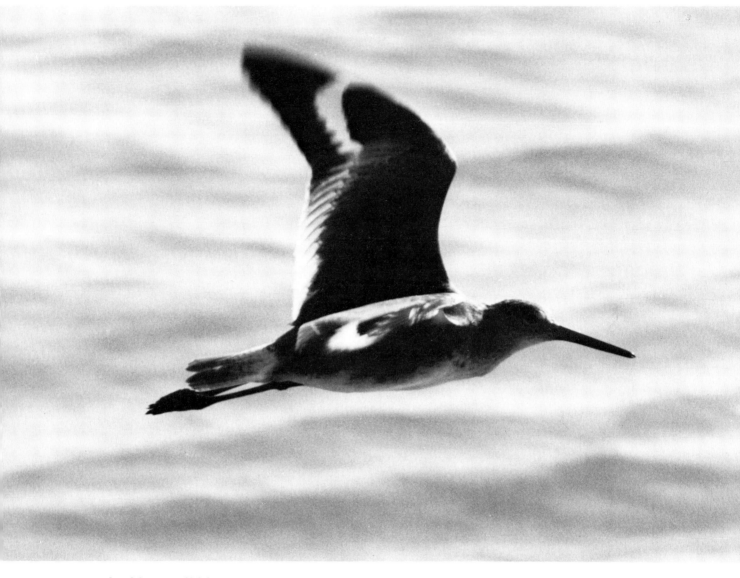

want to build a small block for the camera to rest on. If you're right-handed and left-eyed, or vice versa, an offset stock is useful. A homemade stock has a wide block offsetting the camera two or three inches to the side.

Shoulderstocks are also available commercially, often designed to fold or collapse for easy carrying. They sometimes have a device to adjust the distance from eye to camera, a good feature because this is a really important dimension. A shoulderstock can be a big help in wingshooting, but many photographers feel it's just as easy without. Try one, and use it or not, according to how much it helps your shooting.

Using a longer (400mm) lens brings the bird even closer to the lens, while pushing the background back. The shutter speed permitted blurring of the background and wingtip, yet kept the bird's body sharp.

FOLLOW-THROUGH
Most photographers lower the camera immediately after they take a picture. However, many people start to lower the camera *as* they take the picture. This is disastrous in wingshooting with long lenses. You must learn to *squeeze*, not jerk, the shutter re-

A formidable wingshooting rig! Dade Thornton's camera has a 200–600mm zoom lens mounted on a wooden shoulderstock. It takes practice to push, pull, twist-focus, and shoot all at once—but he's proved it does work.

lease, then keep the camera at your eye for a split second after the shutter goes off. Golfers practice follow-through to improve their accuracy; it works in photography too.

PREFOCUSING

Focusing can be a problem when photographing a bird in flight. You can miss a great shot while frantically trying to get the bird in focus while it comes toward you, passes, and flies away. But it need not be a problem. The solution is to *prefocus* the camera, keep the bird in the viewfinder as it approaches, and fire the shutter when the bird comes into focus. This takes a little practice, and you have no control over the position of the bird's wings at the moment it reaches sharp focus, but it is one of the best ways to get a sharp picture.

If your image is consistently too small, try prefocusing on a closer distance; if too large, focus farther away. With most duck-sized birds, sixty to seventy feet seems about right. Judge your distances accordingly for larger or smaller birds.

The prefocusing technique lets you get one picture (at most) each time the bird passes. If you want more pictures each time, you'll have to abandon the prefocusing technique and use a motor drive. With a motor drive and a practiced trigger finger it's possible to get a series of pictures, perhaps five or six, each time a bird passes. Focusing is the only thing you have to concentrate on, and it becomes easier with practice.

Timing is all-important in wingshooting, but the bird's movements are often so fast you have to just shoot and hope. Bigger birds, crow-sized and up, move slowly enough to allow you to hit the shutter and catch a particular part of the wingbeat. With the woodpeckers you can choose between rapid flapping and wings-folded sailing. With a hummingbird you can choose between hovering and sitting. Geese can be photographed ris-

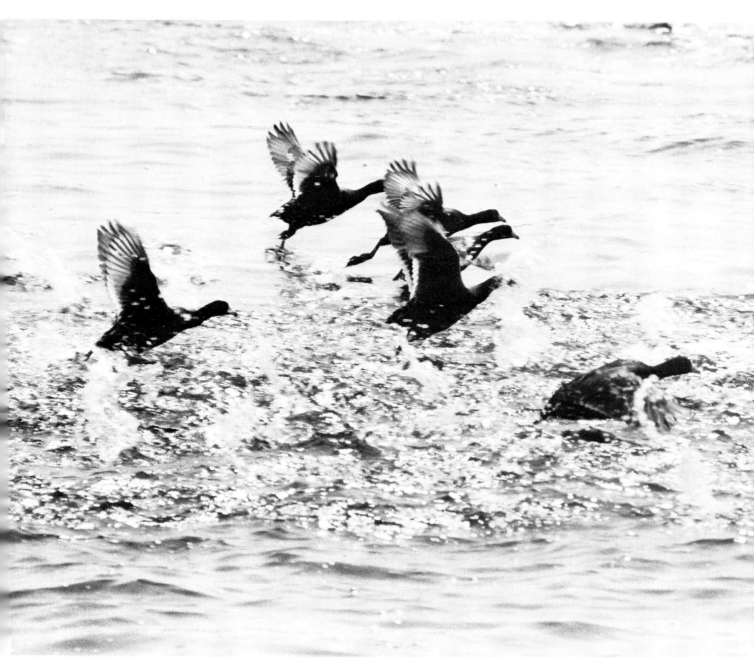

ing, flying level, gliding, or side-slipping to lose altitude. The latter yields some fascinating body postures, but you have to be quick!

USING A TRIPOD
You might think it odd to use a tripod when wingshooting, but it works well. The trick is to fasten the camera on firmly, leave the tripod controls loose, and track the bird in the usual manner. Buy a tripod of a comfortable height—most are too low, and your neck and back get pretzeled. Even a light tripod can help to reduce the fatigue of supporting the lens-camera combination with your arms at all times. Wingshooting with either a

Waterbirds most often take off into the wind, so you can figure out roughly which way they will fly. Then it is a matter of approaching them slowly, changing focus continuously to be sure you'll be ready when they do decide to depart.

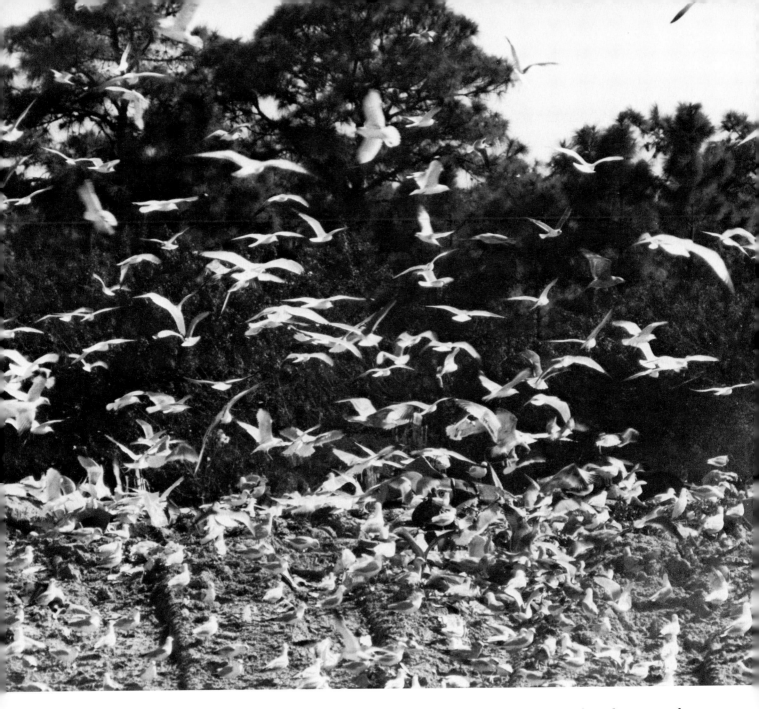

If you figure out where a certain species feeds, you can find them there almost anytime.

tripod or a unipod requires a bit of practice, but there are photographers who use them regularly, swear by them, and take sharper pictures.

FINDING BIRDS IN FLIGHT

The most important factor in photographing birds in flight is to be in the right place at the right time. Sometimes this is obvious—natural flyways attract birds, and you can expect to find them frequenting the same spots. Migrating hawks tend to ride updrafts along cliffs and the windward side of mountains. In the same manner, gulls ride updrafts against sand dunes or the side of an ocean liner. Ducks and geese also have regular flyways. Smaller birds have regular routes to and from their nests, watering holes, and feeders. By observing birds' flyways you can get into position to shoot some great pictures.

78

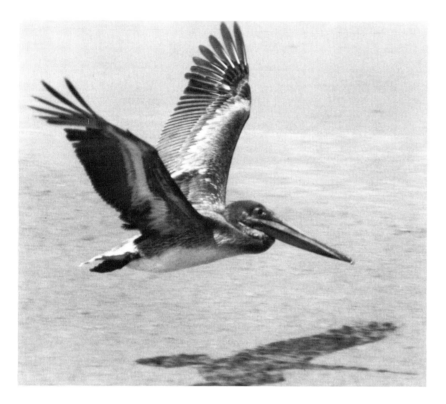

Pelicans are great subjects for wingshooting. They are comical, appealing, and fly slowly enough so that you have a fair chance of catching any part of a wingbeat that you wish. When they fly low, you can even include their shadows on the water. With a motorized camera, sequences of their feeding/crash dives are possible.

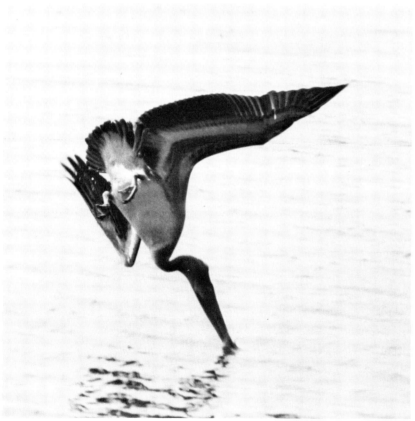

It may be tricky to try to influence the flight patterns of a large hawk, but in this case a large dead fish, laid at the water's edge, brought an osprey in for a closer look. A sizable, prominent pile of a bird's favorite natural food will usually attract your subject's attention.

Terns are independent-minded and have few natural enemies. Because of this, they don't normally fear man. If you can spot where they are feeding, a stream outflow, for example, you can get quite close. Tossing bits of fish will also work to attract them, especially if they are accustomed to being fed that way.

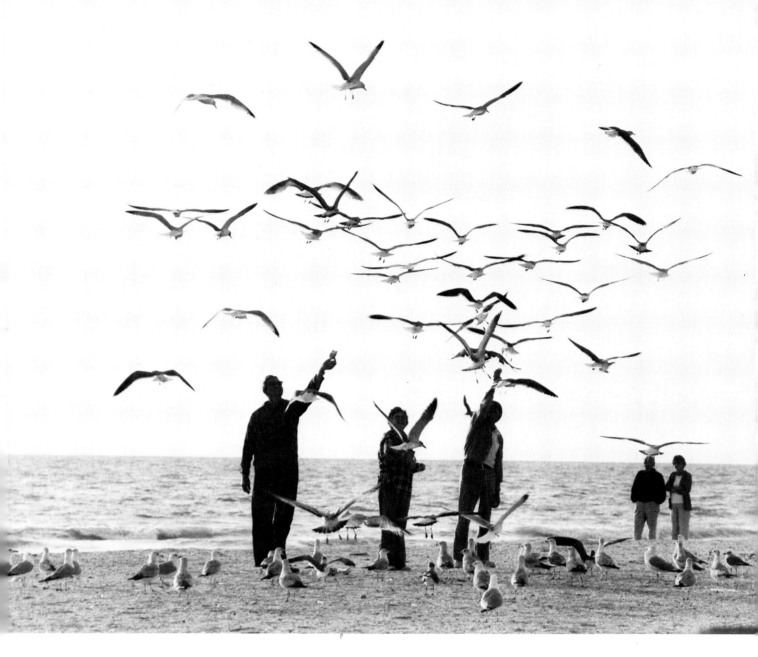

INFLUENCING BIRDS IN FLIGHT

There are ways you can control a bird's behavior and flight routes. By having an assistant walk around a bird, then slowly toward it, you may make the bird fly toward you when it takes off. At the beach, a shorebird or seabird will turn toward the water, a land bird toward the trees; thus you can know roughly which way it'll go. If birds are flying along a shore, they'll fly out around you, then back in close to shore. The better you are concealed, the closer they'll come. Another way of influencing a bird's movements is to stay near a nest; a bird may come back several times, trying to reach young or eggs. Some may even hover over you briefly. All present good opportunities for photography. Be sure not to keep this up very long, however; chicks and eggs can easily be killed by too much chilling or sunshine. Staying too near a nest can provoke some birds to peck your head, even attack you. This is a time when you should know what you're doing, or be with someone who does.

Gulls are a species that is accustomed to being around humans, will eat anything, and is used to being fed in many areas. It is a simple matter to attract as many of them as you could possibly want by tossing bread into the air.

81

Tossing bits of food into the air will attract some species of birds, causing them to swoop low over your head. Throwing bread to the gulls at the beach is a prime example. When attracting birds you can use your normal lens or a 100mm lens to good advantage. Have a friend do the tossing, and concentrate on one bird and ignore the rest; otherwise confusion reigns. When too many birds arrive, stop feeding awhile and let them thin out. Terns will come for bits of fish, if they're used to following fishing boats. In this situation you'll have unlimited opportunities and can keep shooting as long as the bait lasts. It is a good time to try out different filters or shutter speeds—the subject and lighting will be the same for all shots, and you can see how the variables change the results.

USING DECOYS

Decoys offer another way to modify bird behavior. A stuffed owl, or even a rough imitation, is enough to work blue jays and crows into a real frenzy. If you're concealed nearby, you can shoot to your heart's content; if you're lucky, a hawk or two

Above. *An overhead shot of an Antarctic skua shows the field marks of this bird—the white wing patches and the short, wedge-shaped tail.*

Right. *Small flocks of geese, like these snow geese, are not only attractive birds in themselves but graceful fliers as well. They often fly in lines and pleasing arrangements.*

A good way to attract whatever small land birds are in the vicinity is to stand still in the woods and make squeaking noises with your lips. Going "Pshhhhht, pshhhhhhhht, pshhhhhht" may also arouse the curiosity of nearby humans as well.

will investigate the ruckus, and you'll have another species. By the same token, a rubber snake may provoke some very interesting behavior (and then again it may not—different species have very different responses to such things). But almost anything is worth a try, and you may never know what works until you try it.

Above all, don't stint on film when shooting a moving subject or trying to catch a particular activity. In a series of shots, one is always better than the others. If you stop shooting after the first one or two, you are gambling on getting good results and almost certainly won't have the best it is possible to get. Your own reactions may be too slow to catch the peak of the action the first time or two. Other things can go wrong, too, so it's best to shoot enough to guarantee at least one outstanding exposure.

Experimenting and practice sum up the whole topic of wing-shooting. In attempting to capture on film a bird in its own element, we are poor earthbound mortals, and anything we can do to help our situation is worth a try. A good flight shot is a joy to behold and a source of pride to produce; it is certainly worth a bit of film and some effort. The process is aggravating at times, so try shooting the easier species first. You'll be encouraged by the results, and you can then move on to more difficult species. If you have any success with something like a swallow in flight, you're in the ranks of pure genius.

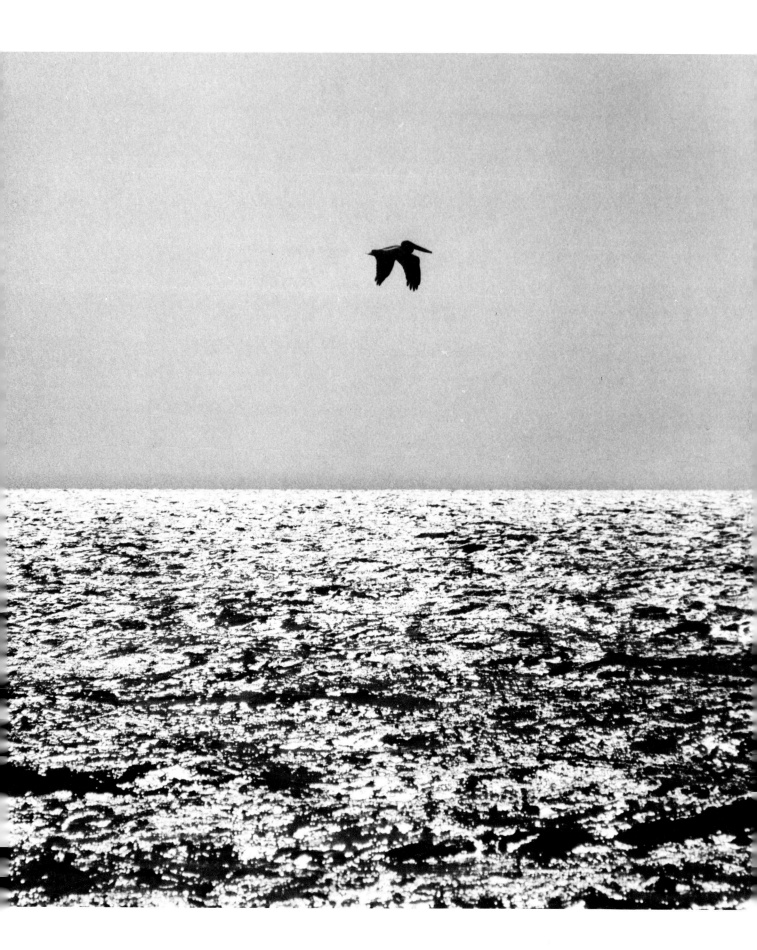

CHAPTER FIVE
PHOTOGRAPHING BIRDS IN NESTS

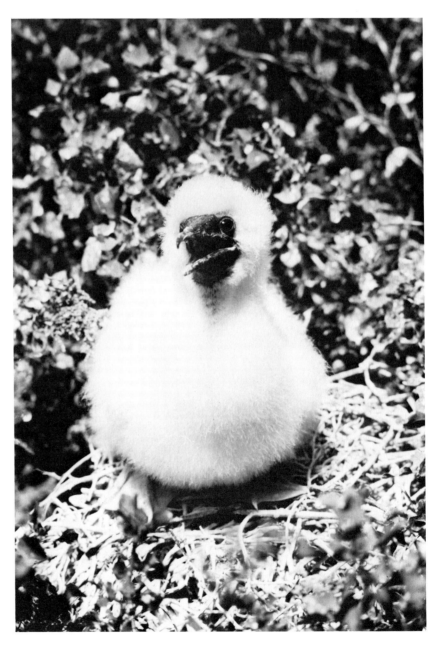

Photography at or near a nest can be very rewarding for the photographer, but too much intrusion can be fatal to eggs and nestlings. Caution is not only advisable—it's vital. One thing you do not want to do is kill the birds you're attempting to immortalize. More than any other time, this is when a knowledgeable assistant is important, a biologist or ornithologist ideal. Too much disturbance early in the season will often make birds desert the nest; later, too much cool air or sunshine can kill eggs. You must not keep the parent bird away from the nest very long. When young are fledged, they are very vulnerable. Later on they are a lot tougher, feedings are frequent, and the parents are less inclined to stay away; this is the best time for photography. But you must still use care. For example, don't cut away branches to get a clear view; tie them back instead, and release them when you leave. Cutting them exposes the nest to that much more weather, as well as to the eyes of predators.

Finding nests seems to be easy for some people and nearly impossible for others. Here again, knowledge is the key. Knowing where to look for the nest of a certain species, and what the nest will look like, is half the battle. After a while you will instinctively begin to seek out the same places the birds do. A good source of information about the nesting habits of most North American birds can be found in *A Field Guide to Birds' Nests* (and *A Field Guide to Western Birds' Nests*), both by Hal H. Harrison (Boston: Houghton Mifflin Co.). Both these books are part of the Peterson Field Guide Series, and Harrison is probably the world's top nest photographer.

FINDING NESTS

Hiking around in the wintertime, with sharp eyes and a notebook, lets you see where last year's nests were located. This year's probably won't be far away. Make some notes, especially if you do a lot of hiking; things look much different when leaves are on the trees. Pile up some rocks as a landmark. Don't tie ribbons on the nest trees, they attract too much attention from humans, and this won't do you or the birds any good.

Of course you can hardly miss a thousand-pound eagle's nest, or the big piles of sticks that ospreys collect. Finding these nests is not the problem, but getting to them is. Best to leave this to the scientists. You'd have to haul a blind up into an adjacent tree, or build a tower 50 or 60 feet high—and then you might be attacked by the parent birds. Such an attack is no joke; it can be fatal.

Reading about the birds that breed in your home territory will let you know what to look for and where. When spring

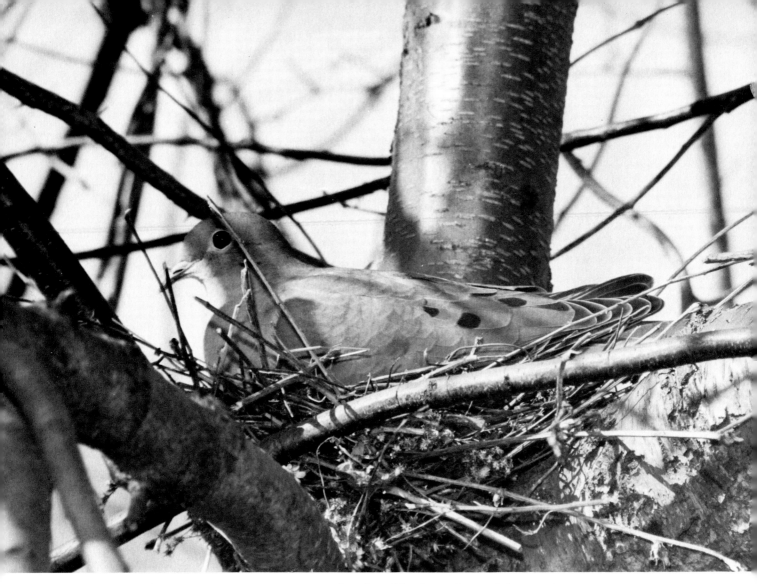

This photograph of a morning dove on its nest was photographed with a weak flash to fill in the shadows and put a catch light in the bird's eye.

comes, do a lot of looking through binoculars and locate several nests. They are often over your head, or in the middle of a thick bush, and correspondingly hard to see. To inspect them, attach a small mirror to a broomstick and extend it over the nest; this way you can keep track of how many eggs there are, when they hatch, and other events. It's best not to check the nest more often than twice a week, though, for safety's sake.

PHOTOGRAPHING A BIRD IN THE NEST

Photography of a bird's activities at its nest is usually done with a telephoto lens, from a blind, or with a remotely controlled camera. Sometimes it's even done with a combination of these. For gulls and terns a blind is nearly essential; for garden birds it's not crucial. A good species to start out with is whatever songbird is nesting in your vicinity. Robins and blue jays are large, tame, plentiful, and tend to nest fairly low and close to houses.

If you want to photograph a fairly shy species, you may have to set up a dummy camera—a tin can on top of a three-stick "tripod"—some distance away from the nest and let the birds get used to it. You can move it a couple of feet closer every time you check the nest. When you're ready to start photographing,

replace the dummy with your camera. You can do the same with your regular camera, over a period of several hours, when you're working with a bird that accepts its approach in such a short time. However, this technique is not very practical in areas where the general public can see the camera. Many people have a compulsion to mess around with anything the least bit unusual.

The dummy camera should not be bright or shiny, nor should your own gear when you put it in place. Tying dark cloth over shiny parts is a good idea, but don't leave loose ends to flap around, as this tends to alarm birds. You can easily sew long sleeves for the tripod legs. If you anticipate rain or dew while your gear is in place, cover it with a plastic bag, cut a hole for the lens, tape the plastic around the lens (with the skylight filter in place), and then cover it with cloth.

A simple dummy camera, made of small cardboard boxes covered with black tape, a tin can, and aluminum foil, is used to acclimate the birds to the sight of photo-graphic equipment set up near a nest or feeder. After a time they will accept it completely, as shown here.

If you're using a flash, you can't cover the reflector, but the power pack can be camouflaged. By all means put a plastic bag over the flash, leave the bottom open, and tape it down so that it won't flap. It's usually best to place the flash a few feet to one side, mounted on a light stand or clamped to a branch, but often the only way to get a clear shot is to put the flash on or close to the camera. Be sure there are no small twigs between flash and nest; the light will hit them and ruin the picture.

Automatic flash units work well in this type of photography, but if they depend on built-in batteries there are two big disadvantages: they run down fairly quickly, and they usually beep at regular intervals. This keeps a shy bird off the nest, and all your work—and perhaps the bird's too—will have been in vain. The answer to both problems is to get a high-voltage battery pack; many units have one available as an accessory that uses a dry-cell battery, often 510 volts, and makes no noise whatsoever. It can also be left on for hours or days with very little battery drain. The only disadvantage is the cost—and the fact that the battery must be discarded when it's shot. But you can get perhaps a thousand shots per battery, and recycling is very fast, perhaps a second or two, so it's really worth it. Wrap the battery tightly in a plastic bag and keep it in the refrigerator when it's not in use—it will last a good deal longer.

REMOTE CONTROLS

Once you have the camera set up near the nest, you must trip the shutter from a distance. The simplest way is to tape or tie strips of wood onto the camera so that they will release the shutter when you pull a string. Use thin black thread for this; some birds try to collect white string as nest material and can get into an awful tangle.

A better method is to attach an air release. This is simply 30 feet of vinyl tubing, a cylinder that screws into the shutter release, and a big rubber bulb that forces air down the tube when you squeeze it. Be sure it is vinyl tubing, not rubber, as rubber expands and causes a delay.

You can also use a motor drive. Some motor drives allow you to plug a long extension cord into the motor and fire the camera with a switch at the other end. The motor, of course, rewinds the camera after every exposure. With a motor drive and this type of control, you don't have to go near the nest until you're through. With an air release you must wind the camera manually after each exposure, then wait for the bird to return. A third type of remote control is radio controlled. Many camera manufacturers offer one as an accessory, but you can also rig one up from the radio transmitters and receivers offered by large hobby shops.

Many birds get used to the flash and the sound of the motor and won't even fly when you hit the button; here is nest photography at its best.

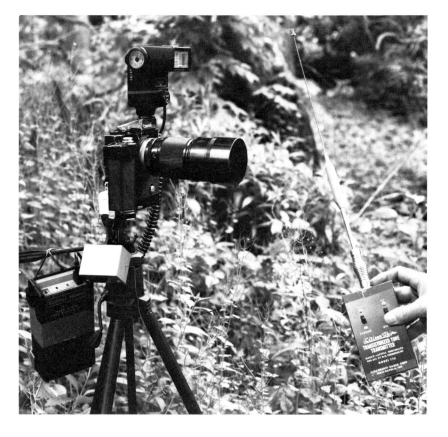

Shown here is a remote-control rig on a camera with a 200mm lens, ready to be moved close to a nest. The high-voltage battery pack hanging from the tripod control powers the strobe, while the small box next to it is the radio receiver. The transmitter is held in the hand at right. Note that tripod is painted black to cut down on reflections.

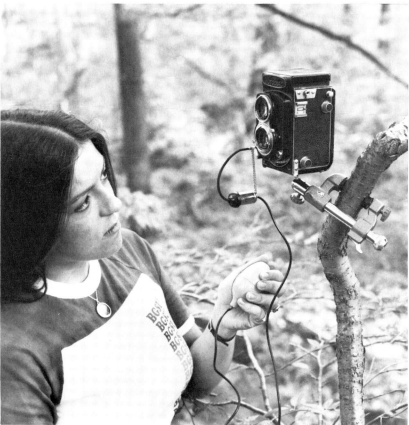

A camera with a tripod socket can be mounted almost anywhere by using a small "clampod." It is a simple matter to set it up on a branch near a nest. The air release will fire the shutter from as much as forty or fifty feet away when the rubber bulb is given a firm squeeze.

Right. It is dangerous to climb up to a large nest perched precariously on top of a dead tree. Branches can break, and adult birds may attack you. Good pictures, however, are possible from ground level, but don't keep the parent birds away from eggs or young too long.

Facing page. Adult birds will come back to the nest when they feel it is safe; often you must back away a little before they will return. When they return timing is the crucial thing to consider. It is much easier to work efficiently if the camera is on a firm tripod. After the parent bird has perched near its nest, it is safe to switch to your longest lens for the detailed closeups that are difficult with a moving bird. A 600mm lens caught the sharp eye of this osprey.

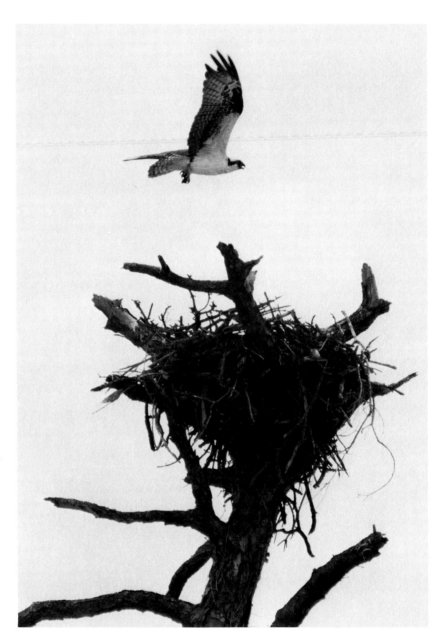

NESTS IN TREES

For nests higher than your tripod (and there are many), you have to go up a ladder and mount your camera on an adjacent tree or branch. A clampod is good for this as some clampods have a wood screw that goes into a tree trunk. You can also mount a tripod head on a piece of plywood and nail or tie this to the tree, or even lash the whole tripod to a branch, though this is a lot of hardware to hang up.

Even with a remote control it's usually a good idea to use a medium telephoto lens and shoot from several feet away. Just how long a lens to use depends on how close you can get with the camera. Somewhere around 100mm to 200mm works very well with shy garden birds. Gull and tern nests, however, can be shot from ground level, with a normal or ultra-wide-angle lens, for dramatic eye-to-eye pictures.

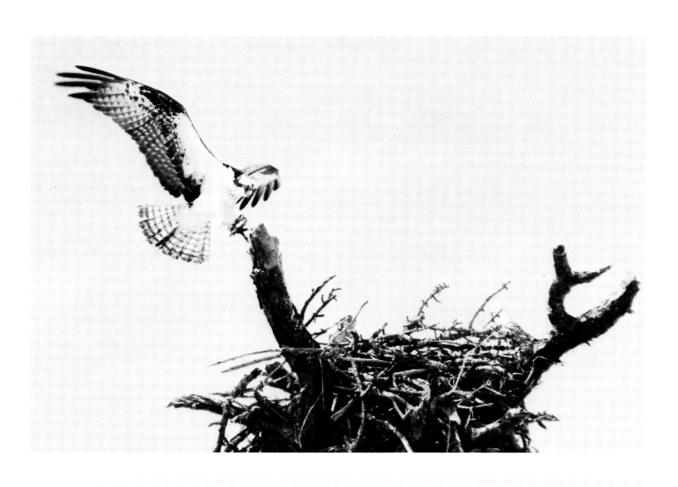

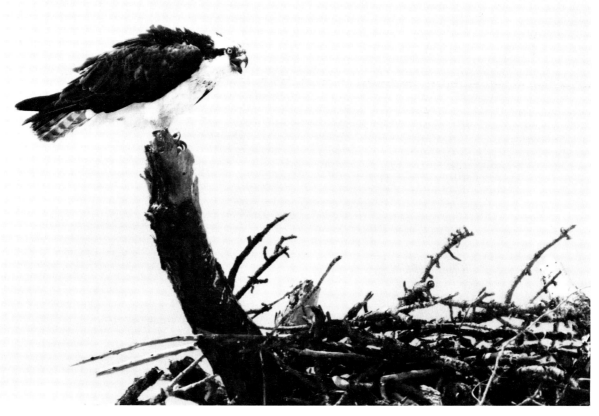

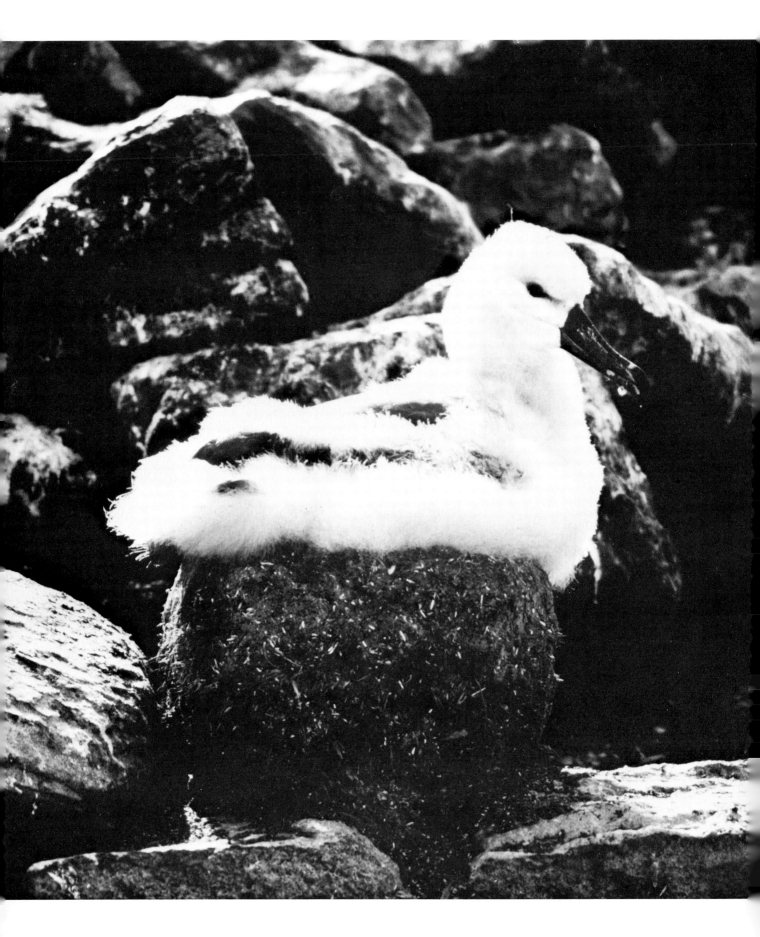

A visit to a gull or tern colony is quite an experience, but should be made with caution. Do not enter the colony itself because of the danger of crushing well-camouflaged nests and eggs. Cover your gear with plastic bags, wear a hat and a raincoat, work only from the edges of the colony, and keep your visits short. Remotely controlled cameras are a joy to use for these nests—set them up, retire to a distance, and watch with binoculars, hitting the button whenever a shot looks good.

Long-legged wading birds commonly nest in mangroves surrounded by water, and you must use boots or a boat to get to the nests. Most are at least fairly tolerant of humans, and the young are so gawky and awkward they're beautiful. But it's a messy business, not helped in the least by young pelicans' habits of regurgitating half-digested food onto anyone below.

The equipment you should use to photograph nests on the ground depends so much on the situation and the character of the bird that it's hard to generalize. Ground-nesting seabirds are one thing, and ground-nesting land birds another. You can walk right up and photograph some species. Others won't permit this but are nonchalant enough to sit on the lens after you leave, while still other species desert the nest if you set up your equipment a hundred yards away. Once again, knowledge of the habits of certain species is necessary.

WATER BIRD NESTS

Woodpeckers and other cavity nesters pose a special problem in that most of their activities are hidden from view. Good pictures can easily be made of a parent bird in the nest opening or perched at the entrance—if you're lucky. When the young are half-grown, they may stick their heads out to eyeball the outside world, and very appealing pictures are possible. But showing what goes on inside the nest gets complicated. Some dramatic life histories have been shot by preparing a nesting log, setting it out, and hoping the birds will select it as a nest site. To make one, saw a log in half lengthwise, and install a pane of glass on the front half (with the hole) before replacing the back

CAVITY NESTERS

Although finding nests may sometimes seem to be an impossible task, at other times a bird's nesting habits will make it simple, provided you can get to the right part of the world. Here a young albatross sits on her nest in the Falkland Islands. Remember, though, even if you are able to approach the next closely, it is better for the bird's welfare to stay back and use a moderate-length telephoto.

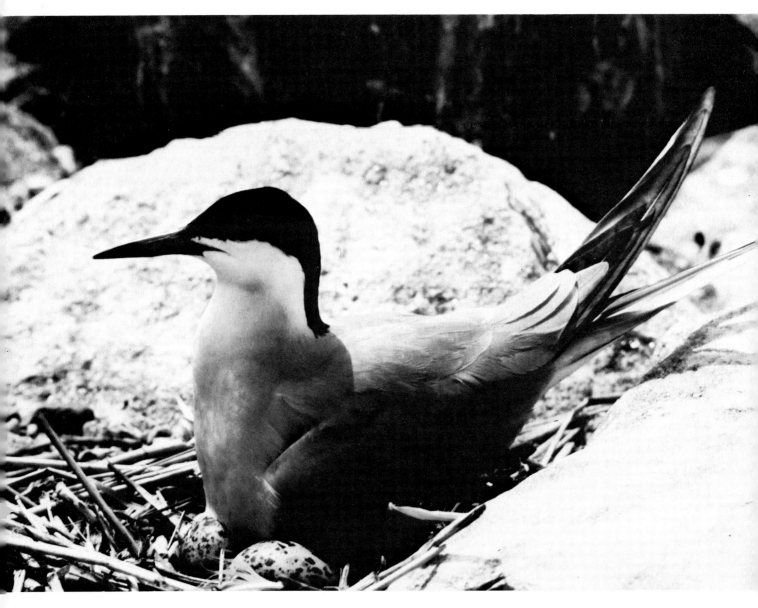

Terns are great subjects, but it is very important to work only around the edges of a colony, for their welfare as well as your own. This common tern was photographed from a blind, with a 200mm lens, from about twelve feet away.

half, suitably hollowed out. Then, after the nest is active, you can ease off the back half, and voila! You have eggs and young right there behind the glass and easily photographable—assuming the parent birds allow it.

Birds that nest underground can be handled in the same manner, but no one should attempt any of these procedures without ample knowledge of the habits of that particular species. If you have access to a summer cottage, barn, or outbuilding, you can easily create a desirable nesting habitat for swallows and sparrows by nailing a box over the inside of knotholes. Even a nailed-on juice can will probably be used as a nest site, and you can hinge the bottom or replace it with a piece of glass, then cover this with cardboard to give the birds privacy. A blind (see next chapter) must usually be used to photograph any glass-

backed nest cavity, and sometimes long hours are required to get each successful shot. In fact, a blind is a valuable tool in all types of nest photography, even when a remote-control camera is used.

There are other nesting situations in which both the use of a blind and looking into the nest cavity are impractical. One such is a martin house, populated by many pairs of birds. Trying to back any one cavity with glass in all likelihood would cause all the nesting birds to go elsewhere. But delightful pictures can easily be made of all the outside-the-cavity activities—the bickering that goes on between such close neighbors, the general hustling, bustling life-style of these beautiful mosquito gobblers.

Though nest photography must necessarily be seasonal, it is

Snuggling down on her eggs, a song sparrow eyes the camera suspiciously. The barberry branches sheltering the nest were tied back, and a radio-controlled camera with a 200mm lens and flash attached was set up on a tripod for this photograph.

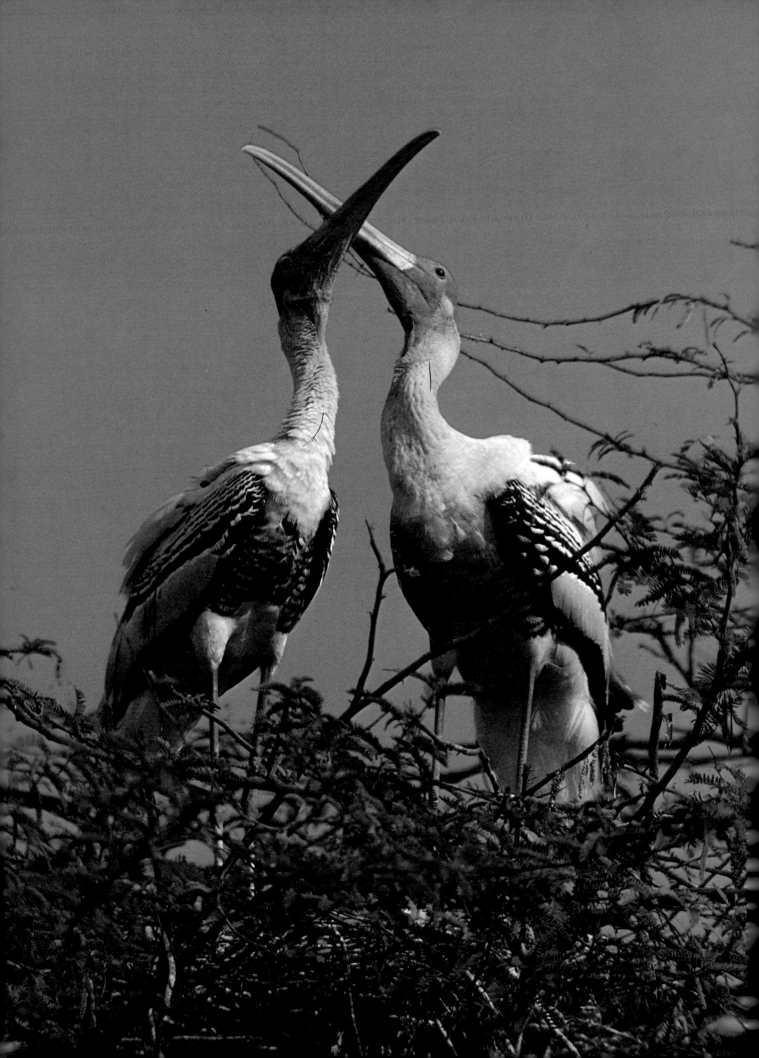

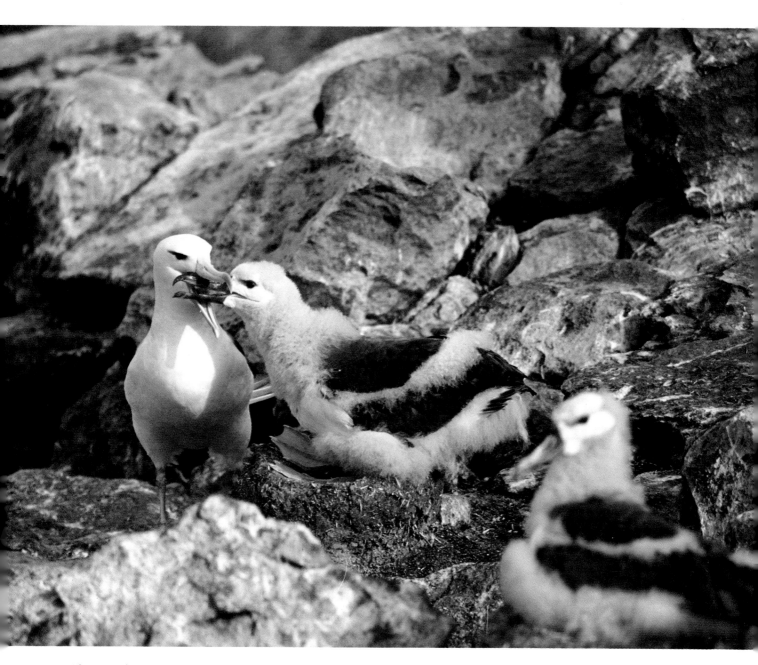

Above. *Graceful in the air, but less so on the ground, black-browed albatross are excellent subjects. Even in the wild they don't mind humans, and no blinds are necessary.*

Left. *Certainly one of the world's most attractive storks, these painted storks were photographed greeting each other near their treetop nest in India's Bharatpur Sanctuary.*

surprising how much of the year can be devoted to it. Different species of birds nest over a span of several months, and some raise two broods, lengthening the active-nest period even more. After the leaves fall, you can prowl and search out the old nests and make plans for springtime photography. And winter evenings can be spent creating habitats that might promote nesting—bluebird boxes, wood-duck boxes and kegs are prime examples. Even planting shrubs and trimming branches can improve an area, in the bird's eyes, for nesting. In general, the nesting season starts earlier in the south and at lower elevations, later in the north and at higher elevations; so a bit of traveling yields even more opportunities. There's usually plenty to do, and the results can be spectacular.

CHAPTER SIX
PHOTOGRAPHING FROM A BLIND

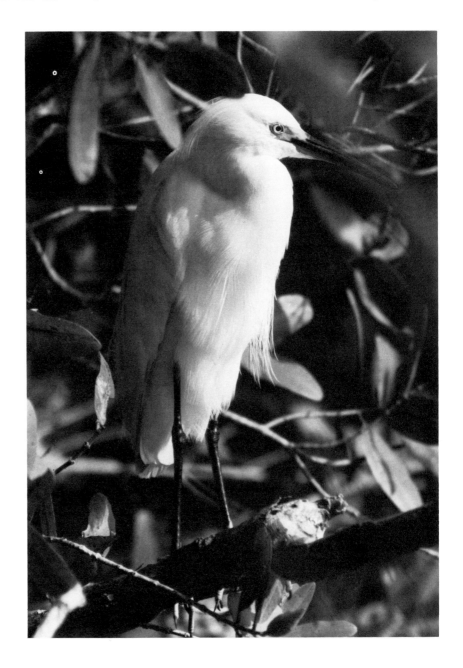

W hat we call blinds the British call hides, which is really a more accurate term since they are designed to hide humans from the eyes of birds. Blinds let you work closely without being recognized as a dangerous human. Almost anything can be used as a blind—a large cardboard box, a few yards of cloth, a blanket, a house, a vehicle, a pile of brush—as long as it disguises the human form, and especially the human outline. You can even sit undetected, silhouetted on the skyline, as long as a bush or something else disguises your outline.

The most common type of bird-photography blind is a small tent of some sort. The traditional type is a rectangular framework of sticks or bamboo, covered with burlap in which several slits have been cut. The photographer enters, sticks the camera lens through a hole, and waits for the birds to c. me back. Frankly, though, burlap is a very poor material for a blind. It's so porous that the person is visible in silhouette and all movements are obvious, and the stuff drops lint like mad. You will itch, and your gear will be full of it. One of the modern cottons, or cotton-synthetic blends, in a dead-grass or dark color, is much better. You can spray-paint camouflage patterns on it if you wish, but it's not usually necessary. If you make your own blind, you should include long Velcro strips or vertical zippers, with two sliders, so that you can make a hole and move it up or down, as well as peepholes of some sort. Small panels of doubled mosquito netting are better than open holes, but in any case you have to keep as still as possible, and move slowly when you have to.

The best bird blind I've seen was designed and is sold by George Lepp in California. It's a 3 x 3 x 4-foot tent, dead-grass color, put up over a framework of PVC piping. It goes up in no time, and all the parts are color-coded. It has all the peephole and zippered openings you could want, and it weighs perhaps ten pounds. It is easy to see that a lot of thought has gone into the design; the blind even has grommets for tie-down ropes in case of strong wind. The size is just right—enough room for gear, a small folding stool, even a lunchbox. Two small people could use it together in a pinch. The only thing I may add to mine is some extensions and a skirt so that I can use it standing up as well as sitting, which is better for nests in bushes 5 or 6 feet high.

Another off-the-shelf item that makes a good bird blind is a "pop-tent" a hemispherical tent meant for fun at the beach or for kids' camping trips. Unfortunately, most come in bright colors, but you may find one made of olive-drab cloth. You will

TRADITIONAL BLINDS

still have to put in zippers, and a pop-tent is bulkier and heavier, but it will work.

SITUATING A BLIND

Below. Try to wait until you can catch a bird doing something photographically interesting even if it is only causing ripples in otherwise still water.

Facing page. With what is probably the largest wingspan of any bird—nearly five feet— a wandering albatross would be hard to miss. Its soaring, swooping flight usually allows you to follow it with your lens and choose between sky and water backgrounds.

Where you situate a blind is crucial. Sometimes the location is obvious—near a nest, a feeder, or a waterhole. At other times finding the best spot can prove to be a real challenge. Study the scene carefully, trying to figure out where the bird or birds will be. Check the direction of the sunlight, and decide where it will be in an hour or two. Then set up the blind and crawl in. If you're in a fairly large open area, such as a prairie chicken's booming grounds, you may discover you're not in the best spot. Sometimes you can inch closer, or turn a bit to get a better angle, but often when the blind starts to wiggle or slide across the ground the birds go elsewhere, and you'll have a long wait before they return.

Birds are accustomed to animals, too, and may even be attracted to them—like the cattle egrets that feed among and under cows. Using a cow or a horse as a walking blind may not be a common opportunity, but it can be a very effective one. Just walk along, keeping the animal between you and the birds.

Decoys can be used in conjunction with a blind. Waterfowl and shorebirds readily come to decoys, and so do smaller birds. An owl dummy attracts not only hawks (sometimes they actually attack it) but also flocks of frenetic crows and blue jays. You'll have lots of noise and action, if nothing else. If you put duck decoys next to a blind at the beach, or set a gull decoy on top of a blind located anywhere near the water, any bird flying in will deduce that everything's safe because other birds are peacefully sitting there. Decoys can be works of art, with individually carved feathers that require hundreds of man-hours to make; but equally effective ones can be bought, or made out of papier-mache or softwood, or even folded out of paper. For many species a lot of accuracy doesn't seem to matter.

USING DECOYS WITH A BLIND

When you are photographing from a blind, be sure you will be comfortable for a long period of time. No one can keep still, let alone concentrate on photography, while being pestered by pain, irritation, or petty annoyances. Take a stool or folding chair, or pull up a log to sit on. Use a backrest if you possibly can, and wear suitable clothing. Rain is seldom a problem, but

PHOTOGRAPHING FROM A BLIND

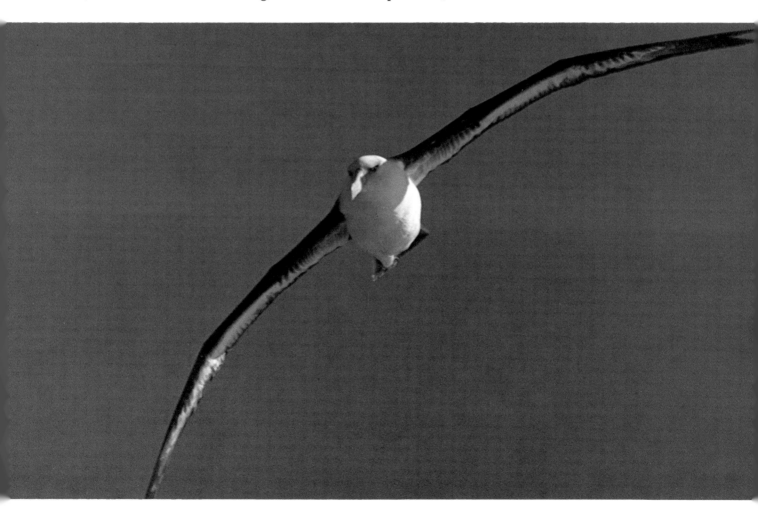

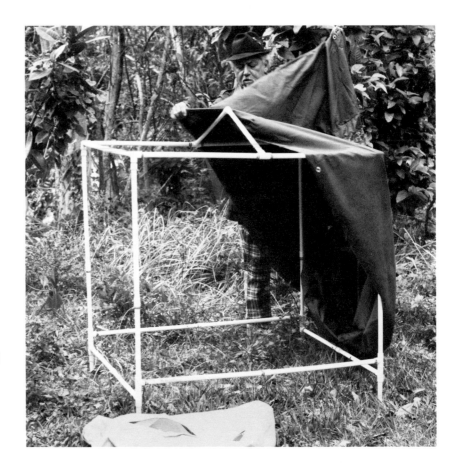

The Lepp bird blind is supported by a lightweight, strong framework of white plastic tubing, all color coded for easy assembly. After the framework is set up in a good location, simply slip on the fabric cover.

Fully assembled and in use, the blind looks harmless enough. The photographer can see out through the camouflage windows, and the lens-hole can be moved up and down as necessary.

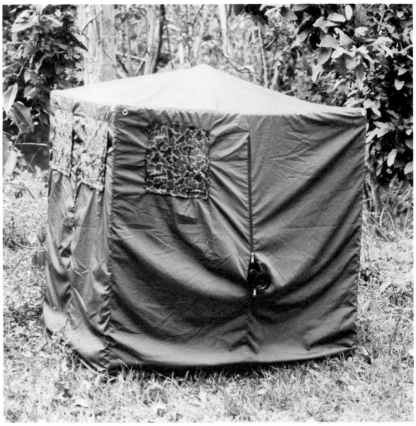

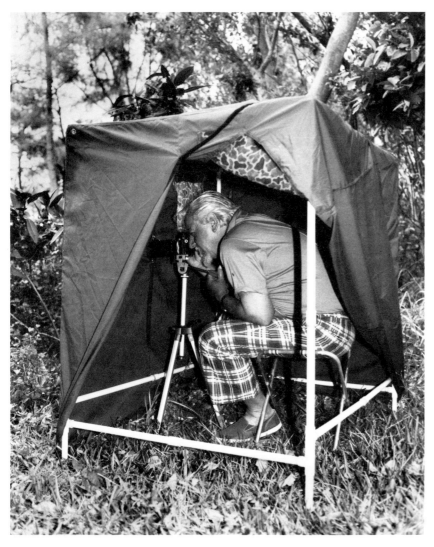

Interior view of the Lepp blind shows there is plenty of room for a stool and other gear. It is also large enough to permit some stretching and wiggling without alarming the birds.

heat and cold can be. Wear several layers, so that one can be taken off or peeled back as needed. Wear button-front shirts instead of turtlenecks or pullovers; you can open and close buttons. Rain usually won't penetrate a blind to any great extent, but it may run under and soak the ground you're sitting on, and so a square of waterproof cloth, used as a minigroundsheet, is very convenient. If you're using a flash, have spare batteries. I can't think of anything more frustrating than running out of flashes in the midst of a great behavior sequence. Don't forget food and a flask of water for long stays. In warm climates, be sure to have a can of insect spray at hand; you will be both wiggly and miserable without it.

On the photographic side, you will usually be using just one lens, but the others should be in your pack and at your elbow. If you're set up with a long lens to include just the nest, one parent, and the young, you will not be able to include the other parent should it be sitting a few feet above the nest. Switching carefully to a wide-angle lens may enable you to get both birds, and the nest, into the same frame.

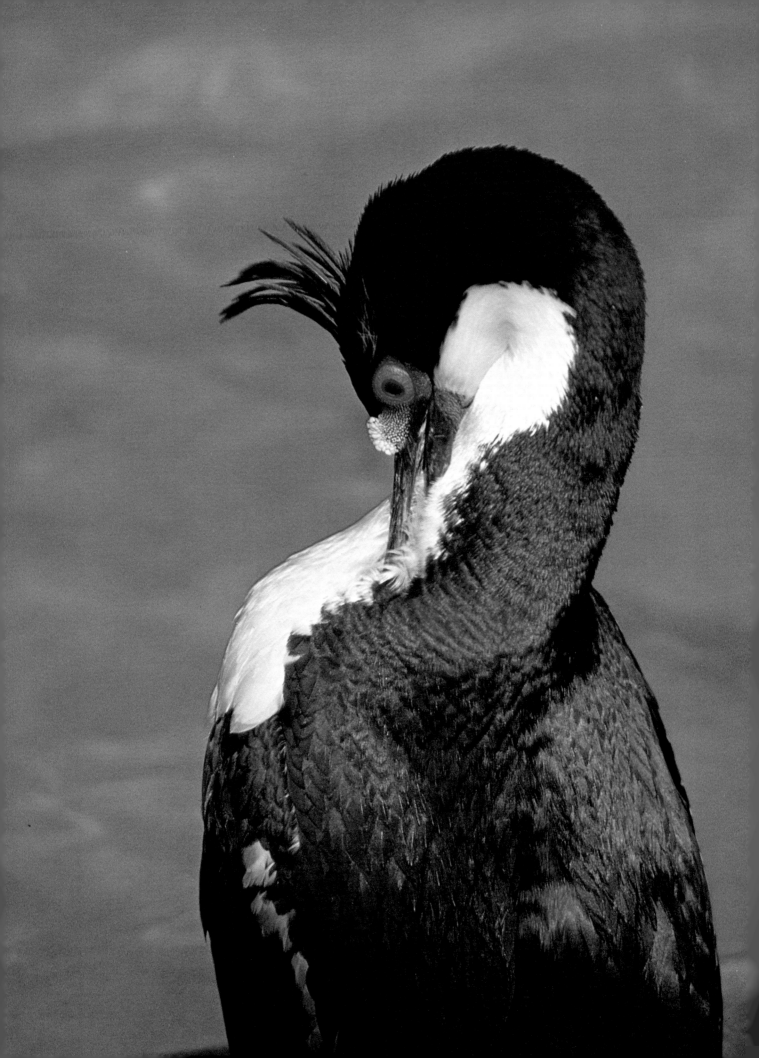

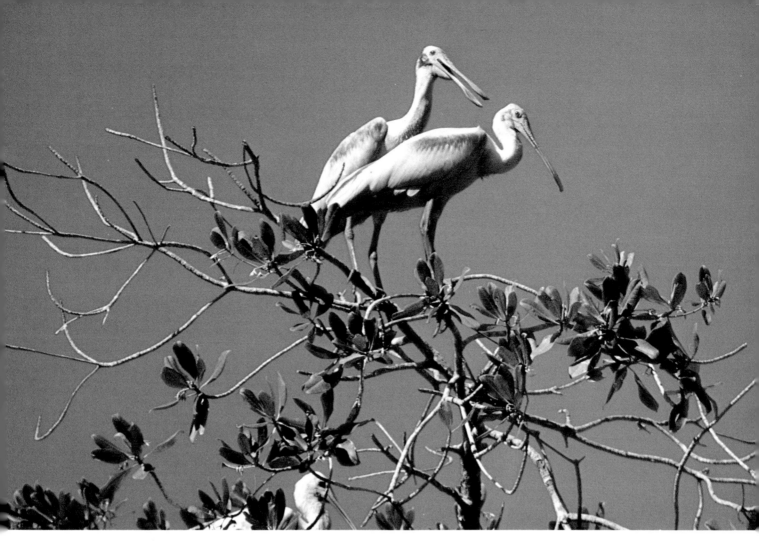

Above. Two roseate spoon-bills, sitting in the top of a mangrove bush, are nicely outlined against the sky. Again, waiting for some activity makes for a more interesting picture.

Left. One of the most attractive of the cormorant group, the king shag has bright blue eyes that don't miss much. The bird's preening behavior makes a particularly interesting shot.

Right. A tiny sunbird, found near Hazafotsy in Madagascar, was photographed with a 400mm lens after a slow cautious approach. The iridescent colors of the feathers change with the bird's movements, and it pays to take a number of pictures to be sure that you got what you think you did.

USING A CAR AS A BLIND

One of the best portable blinds available is the automobile. Most birds are used to seeing cars, and don't normally associate any particular danger with them. In an automobile you can often ease up surprisingly close to a bird without its flying away—if you don't open the door. Keep your telephoto lens handy and ease the car along until the bird gets agitated, then stop. You may or may not be able to edge closer, so switch off the motor (to avoid vibrations), focus, and shoot. Sometimes you can restart the engine and take several shots at decreasing ranges. Your longest lens is probably the best one to use for photographing from a car. You can hand-hold a 600mm steady by raising or lowering it on the car window. Screwing a rubber-covered bolt in the camera's tripod socket will help keep the lens from sliding off the glass. Shorter lenses are simpler to hold steady, but the window support works well for them too. It helps greatly to have someone else do the driving, but caution your long-suffering assistant not to move around while you're photographing.

A sunroof gives you even more flexibility and is great for pictures of birds sitting on wires or in trees overhead. A convertible is just marvelous; you can even set up a tripod in the back, take movies, and do all sorts of interesting things. Or you *could* when convertibles were easier to find. When you are using a sunroof, or any other improvised support for that matter, a beanbag makes a convenient, nonmarring support for a long lens. And surprisingly, beans are the best filling for a beanbag—but don't let them get wet. Sand is too heavy and too hard, and other materials are too light.

Very-long lenses, like this 600mm Canon, can be used successfully out of a car window by using the glass itself as support. An assistant/driver is almost a necessity and both people must keep still in the car to avoid camera movement.

A portable blind is necessary when you go to the bird's nest, feeding area, or waterhole. But when you can make the bird come to you (or your camera), you can use a permanent blind. This can be anything from a carpeted cinderblock building to a plywood shack, erected in a good place for photography. But the best and most plentiful permanent blinds are houses. The birds are used to seeing them, even perching on them, and chances are there are feeders close by. Put the feeders 5 to 10 feet away from a suitable window opening. Get a piece of corrugated cardboard from a large carton and cut a strip the width of the window opening and about 6 inches wide. Cut a hole roughly in the center, big enough for your telephoto lens to slide through easily, and poke a few peepholes with a pencil. Now open the window, set the cardboard in place, close the window, pull the shade or curtains, set your camera on a tripod or table, pull up a stool—and you're in business. You will still have to avoid making noise, and if there's a window behind you your movements may be visible; but normally you can snap away at will, even very close to the birds. You can easily slip away when things slow down, or the phone rings, whereas a conventional blind can tie you down for a long time.

A more durable window blind can be made by coating the cardboard with several coats of varnish, or by making a new one out of Masonite or thin plywood. Chances are you will have changed the design or dimensions after using the window awhile anyway.

USING A BUILDING AS A BLIND

It isn't often that you can perch on a comfortable sofa while photographing birds— but if you lens is sticking out through a board set in a window, and there is an active feeder just outside, you can fire away in luxurious comfort. All that the birds at the feeder see is an innocuous window, with the curtains pulled and a piece of cardboard with a lens sticking through it. A few pencil holes allow the photographer to peek through. Unless the lens wiggles around a lot, or the curtains shake, the birds will continue to feed peacefully.

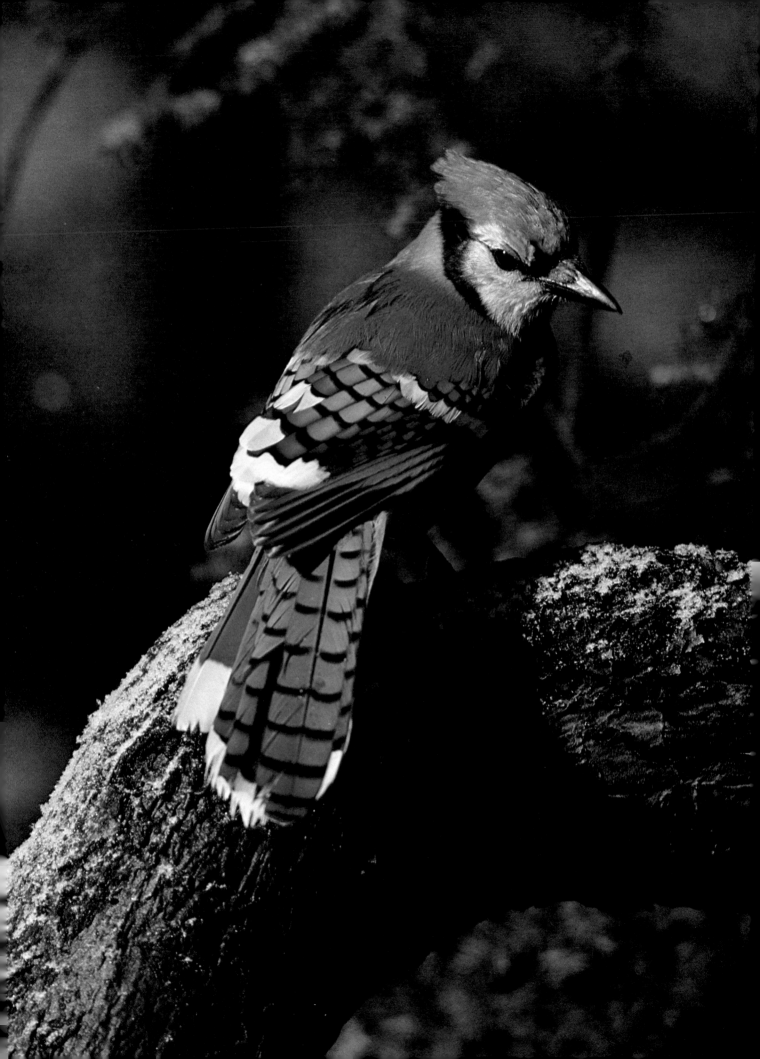

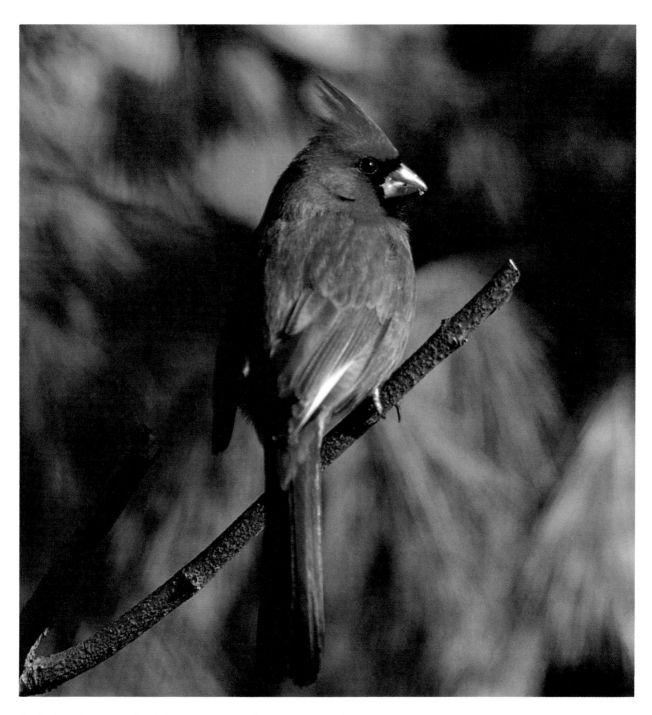

Both the photograph of the blue jay on the facing page and the photograph of the male cardinal above were taken through window-board. While taking the picture of the blue jay the photographer was able to combine two winter pleasures: staying warm and watching (and photographing) birds in the snow.

There may not be a window at the best spot for photography, but there is an easy solution to this problem. Just cut a hole in the side of the house, carefully and neatly of course, and hinge the place you cut out so that you can close the opening when it's not in use. Paint or seal all the cut edges, whether wood, Sheetrock, or wallboard, and cut a strip of plastic to fit over the outside hinge to keep out rain. It may be easier to make such a hole in a storm or screen door. I don't recommend doing either of these things to rental property, but if you own your own house, go right to it.

THE CREEPING BLANKET

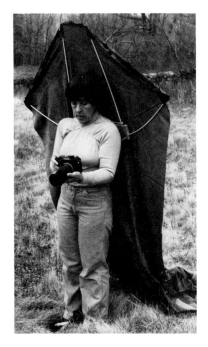

The "creeping blanket" is simple to construct. The only materials required are a few yards of whatever dark cloth is available, a piece of wood about eighteen inches wide, four dowels, and a band of shock-cord or heavy elastic. The dimensions can be easily modified to suit any individual.

To get good photographs of ground-nesting birds, of any bird on or near the ground in fact, you must get right down to the same level by kneeling or lying down. Regular blinds often don't work well for this, so I use what I call the "creeping blanket." It's just a few yards of suitable material—camouflage cloth or whatever else is dark and handy—hooked over a wooden frame that straps across the shoulders. Wooden dowels keep the blanket stretched out. The blanket goes where you do and leaves both your hands free for photography. A cloth carpet humping along like a stranded flounder may look peculiar to the birds, but it doesn't look *human*, and that's what counts. Aside from crawling through a puddle or over an ants' nest, the only problem with using the creeping blanket lies in having someone see it and come charging up to find out what it is. But even this is only a temporary setback.

CAMOUFLAGE

After a time, with some experience in photographing from a blind and learning to keep still, try working without a blind but camouflaging yourself and your gear. See how well you can fool the birds. Nowadays camouflage clothing is both in vogue and readily available. Sporting-goods and army-navy stores usually have jackets, pants, and hats in stock, and they may have shorts, T-shirts, handkerchiefs, and masks as well. Camouflage clothing is made in a dead-leaf pattern material, usually of rip-stop cotton. This cloth is available by the yard if you want to sew your own cases or whatever, but it may be hard to find. There is a stick-on camouflage-pattern tape available that works well to disguise long lenses, tripods, and such. Dark gloves and a mask will camouflage your hands and face. You may look foolish at the supermarket in camouflage clothing but it can be a godsend in the field and is well worth trying. However, do not wear camouflage during hunting season, or any-

where, anytime, if you suspect poachers may be active. This is just too risky under any circumstances.

There may be some purists who get upset at the idea of using a blind to photograph birds, just as they do about feeders. To them, bird photography is a game, a sport, and fooling your opponent isn't in the rules. But if your aim is to get the best possible pictures, I suggest you use bait or blinds or anything else to accomplish it. The results are well worth the effort.

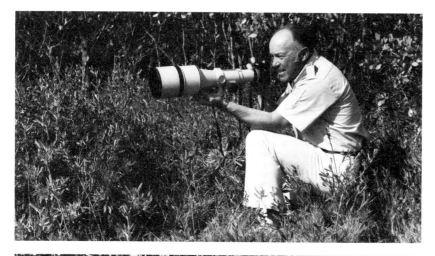

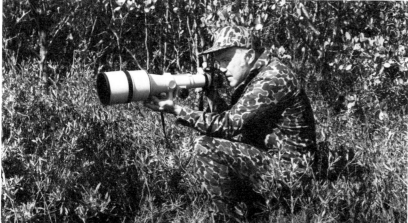

Without any special clothing a photographer and his equipment stick out like a sore thumb. Matching colors to background (white for snow, dark for woods), helps a little, but still presents a uniformly colored object on a field of broken outlines. Wearing camouflage clothing, with its mottled patterns, makes the photographer blend in and almost disappear. For the best concealment the camera and lens, and the photographer's face and hands, must also be covered.

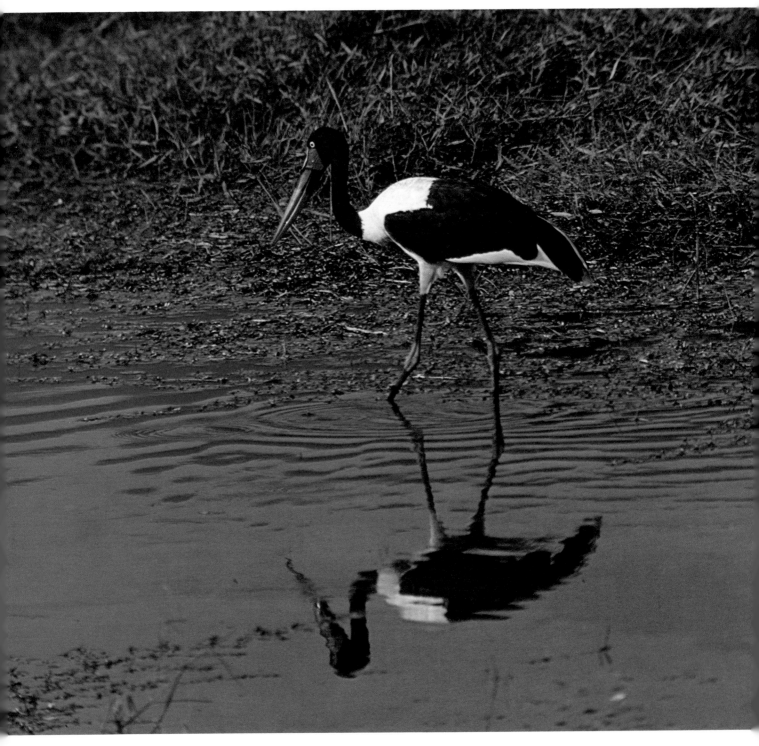

Above. The saddle-billed stork of Africa normally hunts along the shores of streams. With the stream between itself and the photographer, this stork felt secure enough not to flee. He was photographed with a 200mm lens from about a hundred feet away.

Right. It would be extremely difficult to get this close to a king vulture in the wild, so this one was photographed in the Frankfurt Zoo with a 100mm lens. The diffused light of a cloudy day rendered the soft colors accurately and attractively.

114

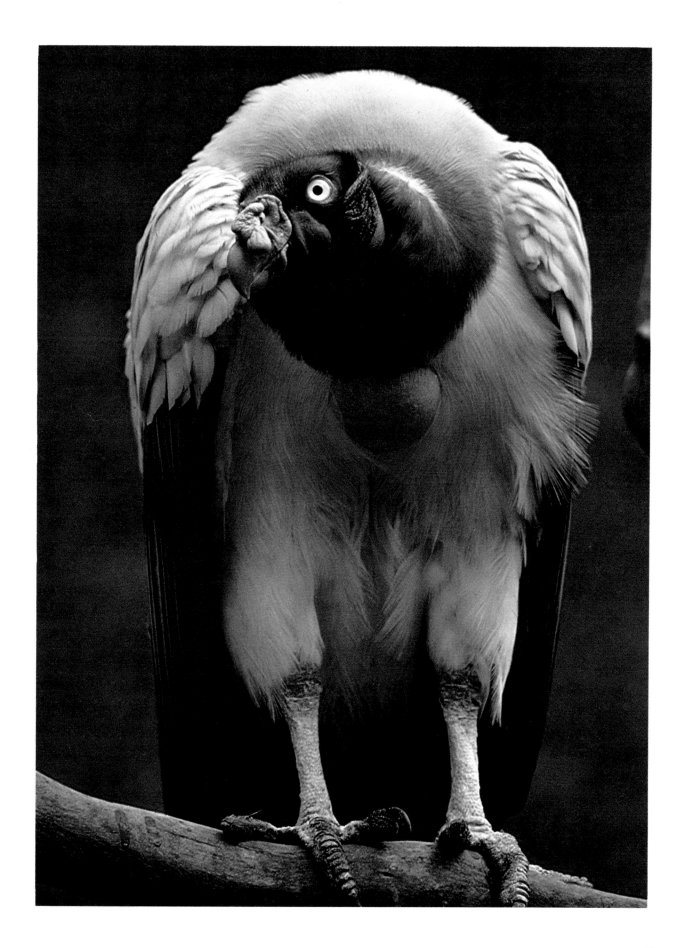

CHAPTER SEVEN
PHOTOGRAPHING BIRDS AT FEEDERS

There are several ways to get a bird close to the camera. Calling to them usually won't do it, but setting out some desirable food often will. Most of any bird's waking hours are spent in gathering food, and just about all species can be enticed with one or another sort of food. For these reasons the bird feeders that are familiar everywhere offer some of the best opportunities for photography.

FOOD FOR BIRDS

The most common feeders hold one type of seed, or a mixture of seeds, designed to attract the different bird species common in gardens and backyards. This "wild-bird mix" is mostly millet, small round seeds that some birds eat but most ignore. Well, that's not quite accurate. They don't ignore millet seeds; they throw them far and wide as they seek out the sunflower seeds in the mixture. For most birds sunflower seed is a better choice, despite its higher cost. Most of the common birds like it.

Peanut butter is another nearly universal favorite, as is waste kitchen fat or suet. One simple way to collect waste kitchen fat is to keep a grapefruit rind near the stove and pour the waste fat into it. Set the whole thing out when it's full and discard it when it's empty. Raccoons and other nighttime visitors may even cart the empty rind away for you. Fatty foods also bring in woodpeckers and an occasional catbird. Doughnuts are also good for attracting birds—buy the day-old ones at the supermarket. Chickadees and nuthatches will perch on them and munch away, and a hungry blue jay may even grab a beakful as it flies past. Peanut hearts are good, when they're available. Even cheese attracts some species. The best reference book on bird food I know of is a delightful British publication, *The Bird Table Book*, by Tony Soper. It's out of print, unfortunately, but worth looking for.

Remember that a plentiful supply of food may entice birds to stay north in the fall when they would normally migrate south, and if feeding is done in the autumn it must be continued throughout the winter months. To stop supplying food would seal the doom of the very birds you have attracted.

COMMERCIAL FEEDERS

Commercially made feeders are usually designed to hold a quantity of seeds or suet. There are three general types: hanging, pole-mounted, and shelf feeders. If you buy one, make sure it has some sort of rainproofing—a cap, overhanging roof, and drain holes in the bottom—otherwise, feed rots and both you and the birds have a mess. Hanging feeders are usually suspended from a branch or roof. You can also use a trolley wire,

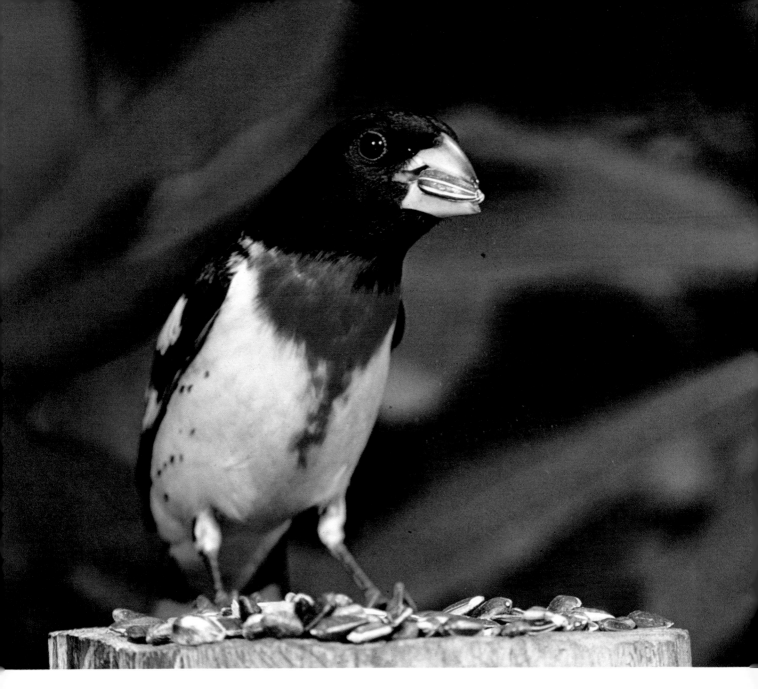

There are times when the camera records things the human eye has missed. This picture of a rose-breasted grosbeak was taken with a high-speed flash and shows a stream of dust falling out of the sunflower seed the bird is cracking open. To take this picture, a remote-control camera with a 100mm lens was set up a few feet away from a feeder.

like an old-fashioned clothesline, to haul the feeder in for filling and pull out again to where the birds can get at it. Nowadays many feeders are plastic and hold from a cupful to several pounds of seeds. Wooden hanging feeders are made for seeds, peanut butter, suet, or doughnuts. The hummingbird feeder is a special type which holds a sugar-and-water mixture and has a bright red imitation flower to attract the hummers.

Pole-mounted feeders are similar to hanging feeders but tend to be larger; some resemble little wooden cottages. Many have an anti-squirrel collar around the pole—more about this later.

Shelf feeders should have a wire-mesh bottom or drain holes (outside) and are a good way to get close-up views of all the birds that use them. Surprisingly, the movements of people inside the window don't seem to alarm the birds too much. Even some fairly shy birds like the cardinal seem to prefer shelf feeders. Leave the curtains pulled until the birds are feeding regu-

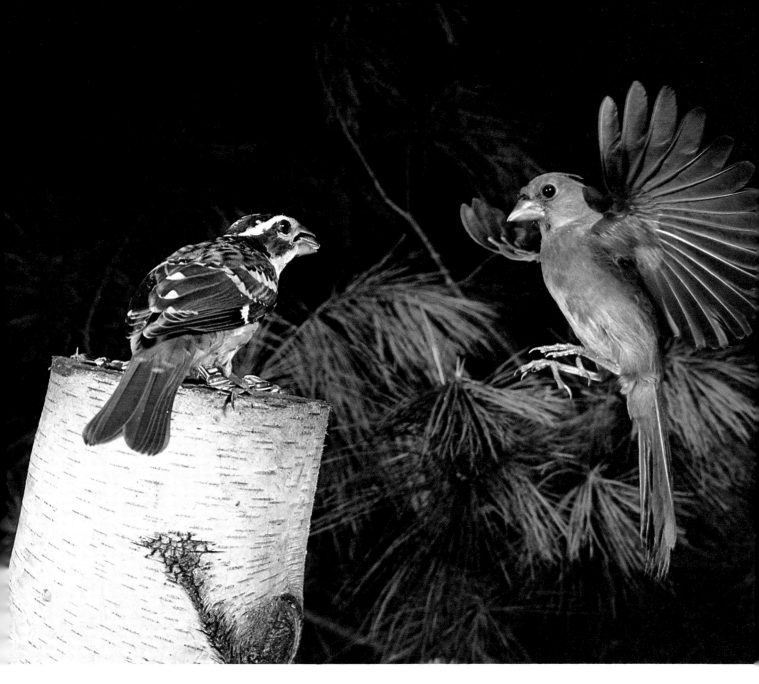

larly—and don't let the family pussycat sit inside the window, licking its chops. There aren't many birds cool enough to put up with that.

Shelf feeders should have a wire-mesh bottom or drain hole so that rain can't pool and stagnate. In fact, good drainage is the most important feature to look for when choosing any feeder; some otherwise fine factory-made ones must be altered to avoid mildew and rot.

I prefer homemade feeders because I can tailor them to particular locations. (I like to tinker anyway.) Start with a shelf feeder made of scrap wood, and use aluminum screening (put on with a staple gun) for the bottom. Most likely you will make some changes in dimensions or styling and later will want to make a new one out of good wood, or add several coats of paint to the

Two young birds—a rose-breasted grosbeak and a cardinal—were caught establishing their pecking order. The high-speed flash stopped wing action at 1/15,000 sec. A remote-control camera was used.

HOMEMADE FEEDERS

old one. (Don't paint the screening, because the paint may clog the drain holes.) This feeder can easily be attached to a windowsill or porch rail, or be made to straddle a rail so that it can be lifted off for cleaning.

Whenever possible, avoid exposed bare metal on feeders, either store-bought or homemade. If you feed birds in below-freezing weather it's possible for their feet, eyes, and tongues to freeze to the bare metal. Though it seldom happens, it's a hazard that's easily eliminated. Don't buy or make a feeder with exposed metal, and if you have one, simply tape or paint the metal parts.

DISGUISING FEEDERS

Setting up feeders doesn't do anything photographically in itself, but it does attract a lot of birds and accustom them to being fed in a certain area. Now when you add backgrounds, disguise the feeders, and set up your camera gear, the birds will still come—you hope. The idea is to make pictures of birds at a feeder look like pictures of birds not at a feeder. Basically, this is done by hiding the food. With a regular shelf feeder on a porch rail (or even a sawhorse), you can lay two branches across it, front and rear, on which the birds will perch while feeding. Or chain-saw a trough for the seeds in a large branch. Or simply upend a broken-off branch and tuck seeds into the crevices. If this is set up where the birds normally feed, it won't take long for them to find it. For woodpeckers upend a branch and drill holes in it, on the *sides*, where they won't be visible at the camera position. Fill these with peanut butter, or carefully pour in hot fat and let it cool. Now you know exactly where the bird will be, in full profile, and your pictures will show how it props itself up with its stiff tail. You can choose between a heads-up, "who's-there?" pose, or a dynamic (and likely blurred) picture of the bird's head pecking the hole. Be prepared to have nuthatches appear and come down on the hole from above. An athletic chickadee or titmouse may also work over such a feeder.

You may not be able to situate a feeder in a spot that has a good background for pictures. The trick is to add a background of natural materials. This is usually necessary with a flash to avoid ghost images. Depending on the species of bird, a good background can simply be pine branches nailed or tied in place. Leafy branches work but must be changed often. A small azalea or rhododendron shrub can be set up behind the feeder and then planted when you've finished with it.

You will find that there is a definite pecking order among the birds that use your feeders. Some sit nearby and wait for others to finish feeding. What could be easier than setting up a twig as a perch, perhaps 3 feet away, and training your camera on that? You can now get many good photographs of a bird-in-waiting

When woodpeckers habitually visit an area, it is easy to lure them to a particular spot by tucking sunflower seeds into crevices of tree trunks or branches. Peanut butter works even better and causes them to stay in front of the camera longer.

120

with no chance of feed showing in your pictures. Change these perches occasionally, and the feeders too, to avoid having all your pictures look alike.

The lighting for feeder photography should be either all sunlight or all strobe. Trying to combine the two seldom works, because you have to shoot at 1/60 or 1/125 sec. for the strobe, and the daylight makes a blurred image; superimposed on this is a sharp image made by the strobe. What results is a "ghost" image that you won't like. Either place the feeder in good sunlight and don't use a strobe, or site it in subdued light and use only strobe. Reflectors work in sunlit pictures, but they tend to scare the birds. Two strobes are better than one; experimentation will teach you where best to set them. Usually, rim lighting from both sides looks better than front lighting or 45-degree placement. With a woodpecker or nuthatch, one front light and one high 45-degree backlight make a very pleasing shot.

LIGHTING

Right. *Sandwiching two slides together is a simple procedure that can produce very effective images.*

Below. *Anything can serve as a feeder. A Christmas wreath becomes more than a decoration when pine cones are filled with peanut butter or suet.*

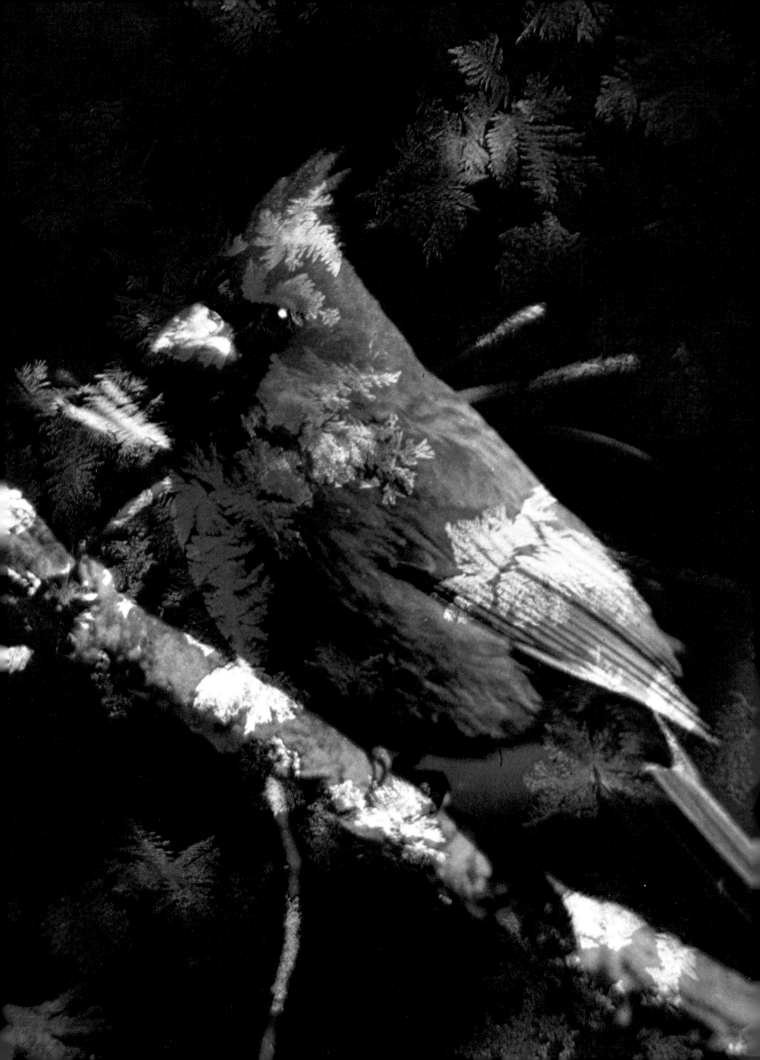

If you plan to do a lot of photography in one spot, consider getting a couple of small inexpensive strobes and mounting them permanently near the feeder. Cover them with plastic bags and tape the bags down. Plug a slave tripper into one unit and a synch cord into the other. Leave the outdoors flashes plugged into house current all the time. This not only keeps them ready to go, but it keeps them warm and dry. (It's a good idea to plug in all strobe units overnight once a month or so, to keep their capacitors in good shape.)

Most strobes fire at about 1/1000 sec., which is too slow to do much action stopping. I now use a custom one that I had designed and built which flashes at about 1/15,000 sec.; this is as fast as you can go without the extremely short exposure causing the color to shift.

The only ready-made, commercially available strobes that stop fast action well are big studio models. These units have oil-filled capacitors, cost and weigh a fair amount, and operate on 110-volt current. Some can use a 12-volt car battery for power. If you go this route, get a "gel-cell" or spillproof battery made for aircrraft or boats; you don't want battery acid spilled on or near your photographic apparatus. These batteries are usually smaller and lighter as well, and costs are comparable.

For all but specialized action-stopping purposes, any of the modern strobe units work beautifully. I find, however, that the automatic modes don't work all that well, so I use the small units in the manual mode and determine exposures with a strobe meter. Feathers require about two-thirds of a stop more light than skin does, so adjust the readings accordingly.

REMOTE CONTROLS

How to set off the camera is another problem. Using an air release is simple, easy, and effective, the only drawback being that you must go to the camera and rewind it after every shot, scaring the birds. A motorized camera avoids this; you simply plug in a wire, lead it through a window or door, and push a switch or button whenever a good picture presents itself. The camera rewinds automatically. The birds may fly, but they usually come right back. After a while they won't even fly. I had a rose-breasted grosbeak that became so tame it wouldn't fly when I walked up slowly and rewound a camera only 4 feet away. The same radio control used in nest photography is convenient to use for feeder photography, especially if it's some distance from the house. It eliminates stringing a long wire from house to camera and completely avoids the potentially disastrous mistake of accidentally plugging the camera motor into 110 volts. All large hobby shops carry radio transmitters and receivers made for use with model aircraft, and these work perfectly with a motorized camera. You need only a single-channel model, but be sure it is a "superhet" circuit, not a "super-regen." Otherwise, every passing taxi or police car will

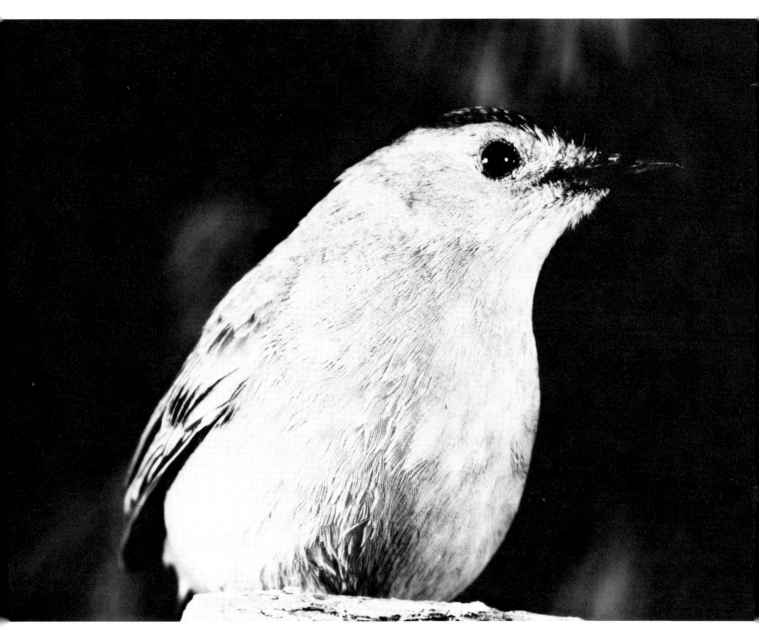

cause the camera to go off.

As in nest photography, a medium telephoto is the best lens to use for feeders, usually somewhere around 100mm. To produce a more alert pose, move in and use a normal lens, or even a wide-angle lens, from up close. The birds will be a little jittery, with crests erected, making more dynamic pictures.

It's very effective to use the whole house as a blind, as discussed in the last chapter. The feeder may be 10 feet or more away, and you'll have to use a 200mm or 400mm lens, shooting through a hole in a board set into an opened window. For small birds, a 400mm lens from 10 feet is just about right. Even longer lenses could be used to produce detail shots and head portraits, but your reflexes must be quick to capture sharp pictures of these moving subjects.

Catbirds can be lured with peanut butter or cut-up raisins and grapes. Two flash units were used here to provide rim lighting and good texture in the feathers. The background is out-of-focus pine branches. The photograph was taken with a 200mm lens through a window blocked by a board.

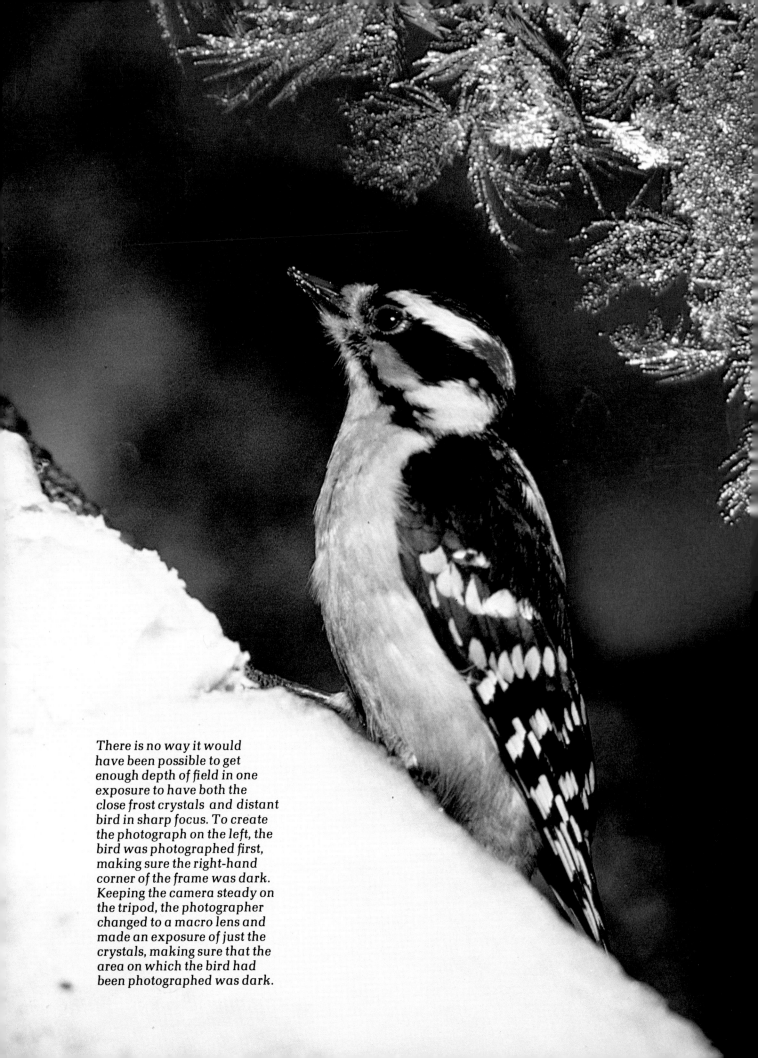

There is no way it would
have been possible to get
enough depth of field in one
exposure to have both the
close frost crystals and distant
bird in sharp focus. To create
the photograph on the left, the
bird was photographed first,
making sure the right-hand
corner of the frame was dark.
Keeping the camera steady on
the tripod, the photographer
changed to a macro lens and
made an exposure of just the
crystals, making sure that the
area on which the bird had
been photographed was dark.

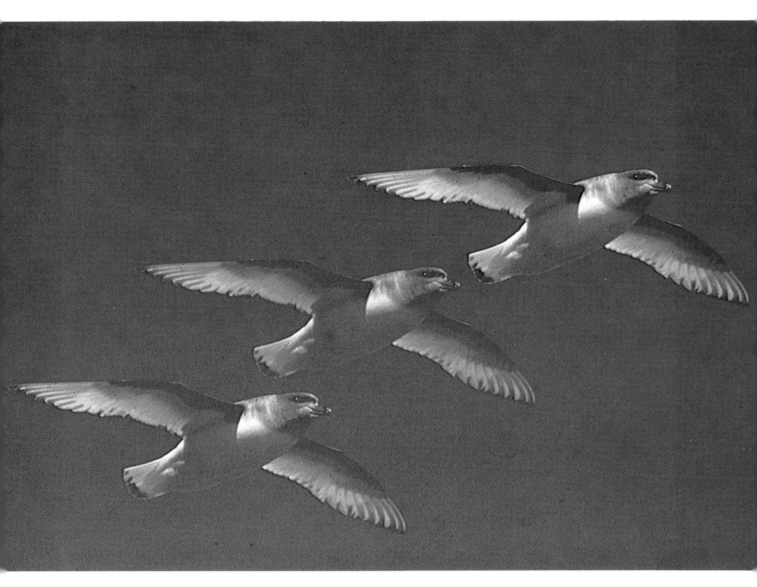

Above. The flock of Antarctic petrels in this picture is in fact only one bird. A slide of a single bird was copied on a slide duplicator, moved a bit, copied again, and then once again. Each exposure was one-third of the normal exposure, therefore the sum of all three exposures made a correctly exposed slide. For the picture on the right, the original slide was copied, flopped left to right, then top to bottom, and copied every time. Each exposure was one-fourth of the exposure needed for a single-copy shot.

MICROSWITCHES AND LIGHT BEAMS

Another way to use a motorized camera is to use a microswitch that closes when the bird lands on a perch or the feeder itself. This rig should have a shut-off inside the house to let you select which birds you photograph; you don't want thirty-six pictures of the same starling. A similar way to make the bird take its own picture is by having it fly through a light beam that triggers the camera. This gear is not available commercially, but it can be built from scratch by a clever electronics tinkerer. Here again, a remote switch should be used to turn the beam off and on, and you should expect to use up a lot of film. Focus on a spot a couple of inches in front of the light beam, because there'll be some time delay.

Focus is not much of a problem, because you know just where the bird will be when the camera goes off. It may of course break the beam with one wingtip or the other; allow for this when you set up the camera. Plan to include about two feet horizontally, and chances are you'll get the whole bird in the frame every time. Watch for a while, and if the birds always come from the same side, you can move closer and tighten up the framing. You take a gamble on what wing position you'll get, but if the beam is close to the feeder, you'll get a wings-extended, "putting on the brakes" pose. Farther away you may get any part of a wing stroke.

Shown here are two switches for birds' self-portraiture. The microswitch with a wire tripper at left was glued onto a household plug for convenience. When a bird lights on the twig at right, the twig bends down until the aluminum foil touches the paper clip. Wires attached to each half of the setup and plugged into camera's motor drive, or a solenoid, take the photograph.

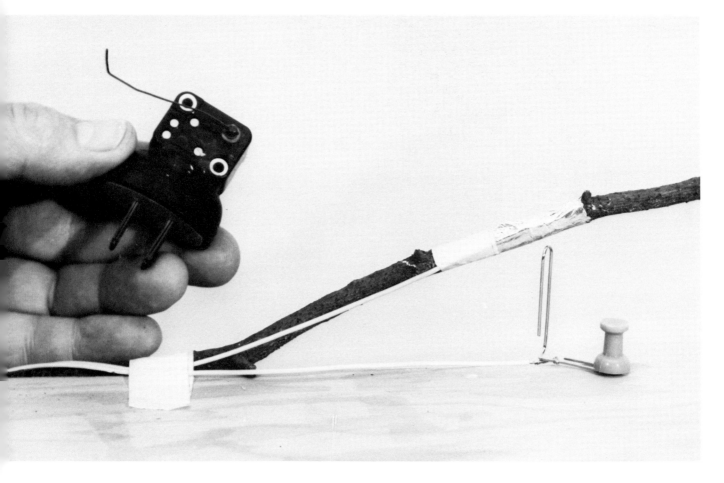

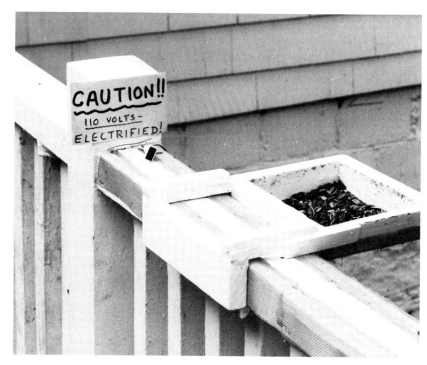

This simple hang-on-the-railing feeder holds sunflower seeds. Strips of aluminum screening were stapled around the feeder and electrified to give squirrels a shock when they try to steal seeds. Be extremely careful when using an electric squirrel guard. Only turn it on when you are immediately present and watching the feeder.

Complete equipment set up for self-portraits of flying birds includes a motorized camera on a tripod, a high-speed flash unit, and a light-beam tripper (small box on lower left). Birds breaking the light beam, indicated by dashed line, will fire the camera and flash.

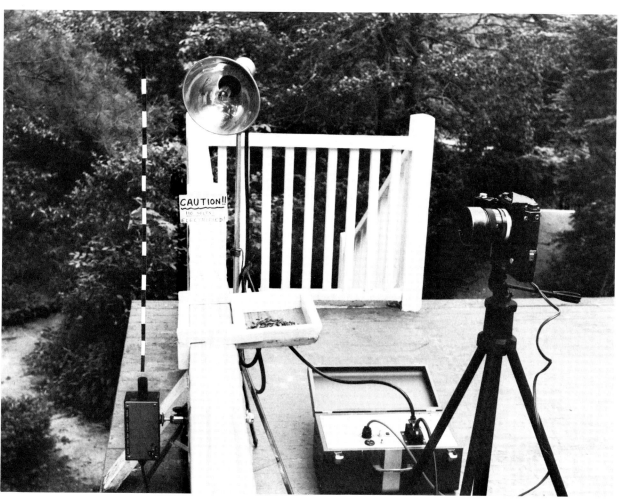

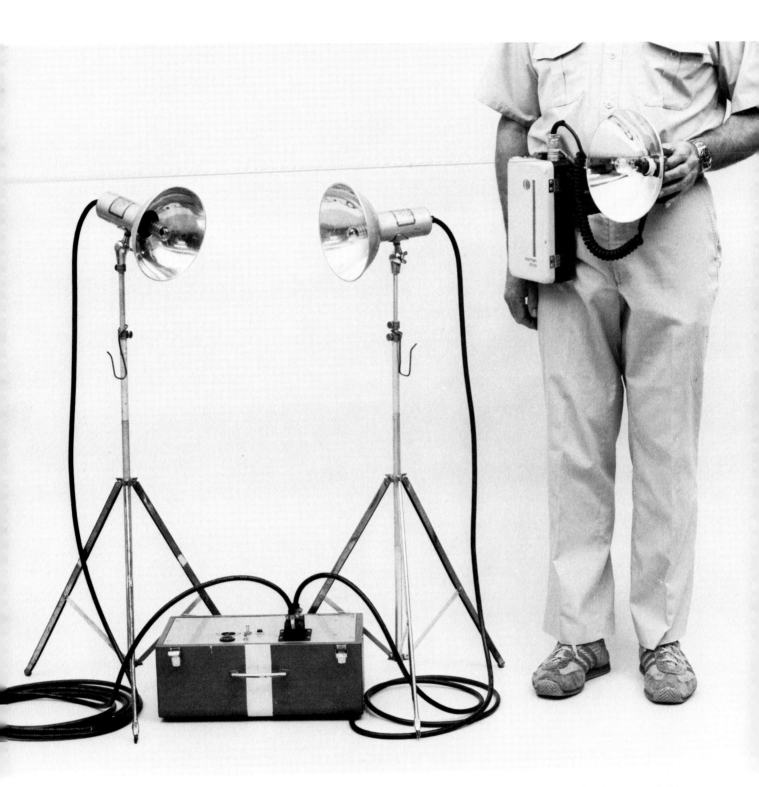

Two powerful flash units are the custom-made "big beauty" (left) with oil-filled capacitors, which fires at 1/15,000 sec., and the belt-carried Norman 200B (right) with telephoto reflector. The Norman is good for a color photography at ranges of fifty feet and more.

I don't need to tell anyone what the bane of all bird-feeder owners is: the ubiquitous gray squirrel. These rascals are always hungry, seem to materialize out of thin air, and go through a pile of seeds like a vacuum cleaner. They also jump on, climb over, and knock down feeders, backgrounds, and cameras. Most people run out, yell, and shoo them away; this has no lasting effect, but it's good exercise for both human and squirrel.

Many bird feeders are supposedly squirrel-proof, which often means it's just a little harder for the squirrels to feed from them. If hanging ones are kept 8 feet from branches and roofs, they may be safe from jumpers. Pole-mounted feeders often have an anti-squirrel collar, which may or may not work. I'm told that using a piece of glass water pipe as a support will also foil them, but I'm still skeptical.

The use of feeders, and photographing feeder-attracted birds, may be considered sacrilegious by a few real purists among bird photographers, but the possibilities are so great, and the results so satisfying, that I for one would hate to give it up. Should anyone take so many fabulous pictures of birds that he gets bored, he can eschew feeders and try something more challenging. But it's doubtful that his "new" pictures will match the quality of the old. I'll stick with the benefits of feeders.

SQUIRRELS

CHAPTER EIGHT
ADVANCED TECHNIQUES

T aking straightforward photographs of birds is much easier than it used to be, and it's getting easier all the time. Manufacturers keep inventing faster and better films, smaller, lighter, and faster lenses, more convenient camera bodies, and useful accessories—zoom lenses, motor drives, and power winders. After a while, any serious worker will be able to turn out high-quality bird pictures as a matter of course and may well turn his or her energies toward something a trifle more challenging—perhaps pursuing the rarer species of birds, or photographing only birds in flight.

Another way to branch out beyond standard bird photography is to utilize certain "special effects" in the pictures. These techniques can produce a totally different interpretation of a common subject, ranging anywhere from slightly modified to unrecognizably abstract. An almost infinite number of effects are possible. Special effects can be produced in the camera, in processing, by duplicating, in printing, by sandwiching slides.

INDOOR FILM OUTDOORS

One of the easiest ways to alter an image is to use a film meant for indoor shooting (a type "A" or type "B" color film) for photographing outdoors. These films are balanced for tungsten light, which is much redder than daylight. Using them outdoors produces a bluish image or "moonlight" effect that can be beautiful. (Using daylight film indoors yields an orangish tone—but of course not much bird photography is done inside.)

VARYING CAMERA SETTINGS

With just camera and film you can achieve several different effects. By overexposing a couple of stops you get a pale, high-key picture, very light and airy. When you underexpose, both the mood and the picture get darker. The further you deviate from "proper" exposure, the more pronounced the effect. Sunsets are especially good subjects for exposure variation. Stay afield next time you're out, set up a tripod, and take a series of pictures: the first one normally exposed, the following one, two, three, and four stops underexposed. The results are enlightening.

Maintaining normal exposure but varying the shutter speed is another way to create unusual images. Slowing the shutter speed from a normal speed of 1/250 or 1/500 sec. lets the bird move during the exposure; how far depends on its speed.

Shooting a fairly large bird—a flying gull or a skimmer—at 1/15 or 1/30 sec. should keep the body reasonably sharp but cause the wings to blur slightly.

At a slow shutter speed use a smooth swing and follow-through if you want the bird's body to be reasonably sharp but

This inquisitive barred owl was attracted by playing a tape recording of barred-owl calls. The bird was photographed with a 200mm lens as it peered down and then again as it flew back and forth under the tree canopy. A slow shutter speed (1/30 sec.) and panning blurred the background, yet let the bird stay sharp.

the background to be blurred. With an SLR the image disappears the instant you hit the button, and your swing must be well established by then as well as kept constant during the exposure. The heavier the camera-and-lens combination, the easier this is. Some photographers have even cast a lead brick to screw onto the camera's bottom to make their equipment heavier. To get proper exposure at such slow speeds, you must cut down the light—often by more than simply closing the diaphragm will permit—so use filters. A polarizer cuts light intensity by more than half, letting you shoot at one slower shutter speed. To go even slower, you must use more filters.

The frantic, thrashing takeoff of a group of coots was emphasized by using a slow shutter speed and panning the camera horizontally during the exposure. The slower the shutter speed (here ⅛ sec.), the more noticeable the effect of panning.

FILTERS In color photography you have a limited choice of filters, assuming you want more or less normal colors. A polarizer does not change the colors in a scene. Two polarizers can be crossed to cut out almost all light, forming a continuously variable-density filter that lets you use virtually any shutter speed you wish. Remember, however, the foibles of using the camera's built-in metering system with polarizers—you may have to use a separate, hand-held meter.

One interesting variation on the crossed-polarizers theme is to use a dichroic polarizer (sometimes called a "Colorflow" filter) as one of them. This type of filter lets you dial in either of two colors, or any mixture of the two. This fascinating effect can be beautiful. Dichroic polarizers are available in red/blue, red/green, red/yellow, yellow/green-blue, orange/green, and green/purple. Still another polarizer comes in a split design, which darkens only half the filter disk and consequently half the picture. This type is useful for darkening the sky but not the foreground. Crossing one of these with a regular polarizer lets you dial any intensity you wish over half the frame. A simple neutral-density filter allows you to use slower shutter speeds without polarizers. These filters are available in various densities. A No. 8 is probably best to start with. It cuts the light by three full stops, letting you shoot at three shutter speeds slower. Slow-speed shots are worth playing with; however, you never know exactly what effect you'll get.

"Regular" filters change colors. Available in many colors and shades, they are intended mostly for black-and-white photography. They are too "strong" for color photography, unless you want the whole scene starkly orange, as in a pale sunset, or blue, for a moonlight effect at high noon. But there are filters in much paler shades that change colors just a little; they tame the redness of late-afternoon light, for example, or add a touch of blue to a foggy-day or approaching-storm picture. Some of these filters are widely available, made for using daylight film indoors and other common purposes, but others are harder to find. One major manufacturer markets a whole range of pastel-shade filters, as well as graduated color filters and split-field filters to change only half a picture's color balance.

One type of specialized filter (commonly called a diffusion filter) softens the edges of an image, producing a halo around all bright areas; you've seen it in misty pictures of brides. Other filters add "fog" to a scene, or produce a sharp image in the center surrounded by slightly misty edges.

The "crosstar" filter causes small, bright points of light to register as tiny crosses on the film; street lights at night, with a nice black background, are an ideal subject. Backlit water, such as behind a duck or a swan, also works well. Two crosstars stacked together can be arranged to produce eight-pointed stars.

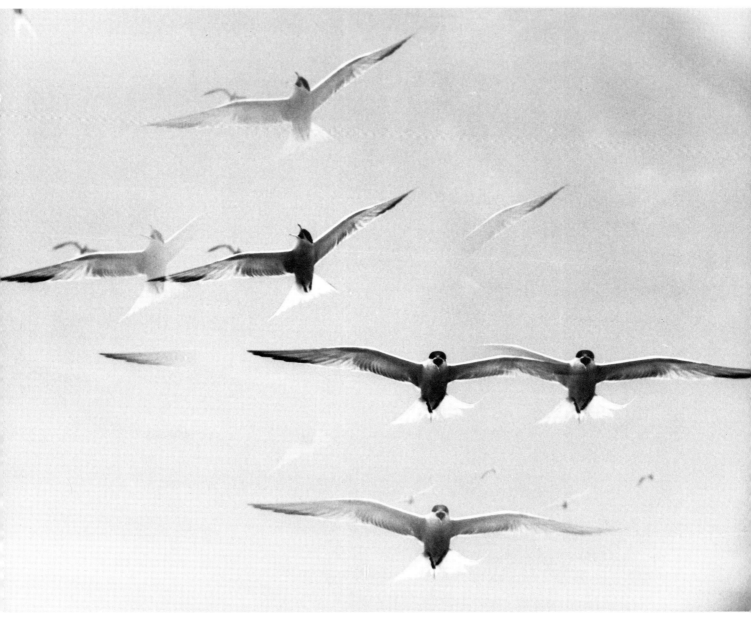

Multiplying prisms fit in front of the lens, like a filter, and do just what the name says—multiply whatever you've aimed the camera at. The 3-P (for "parallel") creates three images lined up like books on a shelf. The 3-C (for "concentric") makes an equilateral triangle of any image. There is also a 5-C prism, prisms that produce six or seven images in a circle, and one that gives a regular sharp image on two-thirds of the frame and smears the rest in a horizontal blur.

But some of the most fun are diffraction gratings, often called "rayburst," "colorburst," or "rainbow"—sheets of clear plastic, mounted in glass, on which 13,400 lines per inch have been inscribed. These are so fine that they break up the wavelengths of light and create wild rainbows of color without pigments or

A 90mm lens with a 5-C multiplying prism attached to the front element was used to get this picture of six terns and two disembodied wings. Changing the aperture will markedly change the picture when using a multiplying prism.

dyes. You can easily see what effect you're getting by looking in the viewfinder as you aim and focus the camera. Remember to stop down and do your viewing at the aperture you'll be shooting with, or you'll get a different picture from the one you see. This is especially important with multiplying prisms and diffraction gratings. You'll have to underexpose by maybe three or four stops when using gratings. Take some test shots, and make notes so that you can re-create successes and avoid repeating failures.

There are other on-the-lens attachments, notably vignetters and split-field devices, that aren't normally used in bird photography. All are discussed in detail in an excellent book from Kodak, *Filters and Lens Attachments*, a book from Amphoto, *The Complete Tiffen Filter Manual,* and another, the *Cokin Creative Filters System*. Both fine publications can be found in large photography stores.

INFRARED FILM

Further creative possibilities are offered by the use of infrared film in the camera, though the results are rather hard to predict.

Infrared film comes in both color and black-and-white. Infrared color film was created for aerial camouflage detection and produces wild, unnatural colors. The most common infrared color film is Ektachrome Infrared Film. Kodak recommends that you use a yellow No. 12 (minus blue) filter with this film. When you do, the film produces blue skies and red foliage. If you use the light yellow filter common for black-and-white photography, the overall cast of the picture shifts toward the magenta. With a medium-red filter, color infrared film produces green skies, orange foliage, and yellow clouds. Without any filter, blue skies are rendered red. The possibilities are almost endless, but it takes a lot of experimentation and luck to produce any kind of consistency.

Most commercial processing labs process Ektachrome Infrared Film, and though the film doesn't have an ASA rating, an exposure index of 160 usually works well under normal outside conditions.

Black-and-white infrared film renders black the sky and water that reflects the sky. Most green foliage is rendered as white or light-colored. Birds may also turn out light-colored. This film is great for achieving a moonlit effect. You should use a dark red filter with black-and-white infrared film in daylight. This filter screens out the blue and green light to which the film is also sensitive.

When you use black-and-white infrared film you must manually change the focusing distance to the infrared focusing index mark on your lens (usually denoted by a small R). First focus the camera as you normally would. Then look at the top of the lens and move the distance number from the normal index mark to line up with the infrared mark.

Both color and black-and-white infrared film must be loaded in the camera in total darkness because the felt light seal on the film magazine doesn't block out infrared radiation. A changing bag comes in handy for doing this if you are in the field.

These specialized films are hard to use, and the results are unpredictable, but with practice you can create unusual and exciting effects with them.

SPECIAL EFFECTS IN THE DARKROOM

So there are lots of things to be done with the camera, at the moment of exposure, to achieve unusual effects. But there are also lots of things that can be done afterward. Some advertising photographers consider the original exposure just a starting point for their work, then retire to studio and darkroom and begin creating.

Once the original slide is in hand, using a slide copier is the next logical step. These devices in effect let you take a life-size picture of any 35mm slide or any part of a slide. They have a camera body, lens and bellows, slide holder, and light source. The light source is usually a weak incandescent bulb, for viewing and metering, and a small electronic flash tube to make the exposure. Because the slide to be copied sits out in full view you can slip behind it colored filters, pieces of tissue paper to act as diffusers, or anything else you can think of to alter the image. You can also double-expose with a copier, combining two different slides into one, or make two-sided or four-sided patterns by flopping the original slide. You can mask off part of a slide and add a sky from another slide. There are infinite possibilities.

If you don't have a copier but do have a macro lens capable of 1:1 (life-size) magnification, you can still play these games. Use a window, or set up a pane of glass with a piece of tracing paper a couple inches behind it. Tape the slide to be copied onto the glass; it is now uniformly illuminated by diffused light coming through the tracing paper. (The most convenient setup is to put the tracing paper on a storm window and the slide on the regular window.) Now set the macro lens at 1:1 magnification (usually the closest it will focus), set up a tripod, focus, and shoot. A focusing rail attachment is awfully convenient for making small adjustments in camera position. Meter and expose normally, or perhaps underexpose a little—experiment to see how your camera handles this. Also be sure the camera is aimed squarely at the slide—lens axis at 90 degrees to the original slide. All copying adds a little contrast, except complicated aerial-image work, and some sharpness will be lost, but you can crop and create to your heart's content. Placing regular filters on the lens lets you add colors; a more flexible technique is to add theater gels or colored cellophane to the tracing paper. Avoid having bright light hit the original slide, or every speck of dust will light up.

The greatest controls exist in the darkroom, and books on printing technique discuss them in detail. They can be used for making prints on paper, as well as on films, to yield transparencies. One of the simplest is the Sabatier effect, more commonly called solarization. The print or film is reexposed to white light during the development, which causes some parts of the image to reverse tones, while other parts remain unaffected. The result is a sort of positive-and-negative effect, which can be very beautiful. Bas-relief is another trick: you make a positive and a negative film image, the same size, bind them together very slightly out of register, then print from this sandwich.

Another way to use such a sandwich is in the line and tone-line technique. But a word of introduction. A normal black-and-white print contains black areas, white areas, and many shades of gray. If you print onto lithograph film instead of paper, and vary the exposure, you can get transparent positives showing just the highlights, all the shadow details, or any of the middle-scale gray tones. These can then be contact-printed to get a series of negatives, showing the same tonal values. A positive and a negative can be placed together, in register, and used to make line and tone-line prints. The two are laid on a sheet of unexposed film in a printing frame, then exposed by a light shone in at an angle, while the sandwich rotates on a phonograph turntable or lazy susan. Many different effects are possible, depending on light angle, sequence of positive and negative in the sandwich, the use of clear-film spacers, and other factors.

The same things can be done in color, and the various gray-tone films can be dyed different colors before the sandwich is reassembled. There are graphic-arts materials that make colored film images without dyeing, but they require enormous amounts of light—1,000-watt bulbs—and special developers. "Color Key" film (made by 3M) is available in art-supply stores, and there is a package of assorted types for trials and testing. Any and all mixes of black-and-white and color negatives and positives, whites and blacks, and all sorts of middle tones are usable. There is literally no limit to the possible combinations. This is usually called posterization, a difficult-to-define term that in popular parlance means making a strong, unusual graphic print from photographic negatives or slides.

Most of these special techniques have been invented and developed by photographic experimenters and darkroom gadgeteers striving for something new. The frontier is still wide open, and almost anything is worth a try.

CHAPTER NINE
WHERE AND WHEN TO GO

In just about all human activities, being in the right place at the right time is important. Bird photography is no exception: both time and place must jibe for best results. You will probably find some bird life in the wrong place, or at the wrong time; but the peak of the action and the best opportunities come only at certain times and certain places.

No matter where you are, your vicinity can be great for bird photography at certain times. Here's where contact with the local birders and the Audubon Society pays off handsomely. Someone will know, or find out, where and when the birding is "hot," and often a short field trip to the spot will be organized. During migrations birds may be everywhere, resting and feeding in droves. In winter they are likely to congregate in the few spots where open water is available, or where there is a good food supply. The areas within a few miles of your home are worth keeping track of at any season.

LOCAL AREAS

Right at home is an excellent place to photograph birds. All your equipment is at hand, there is plenty of electricity and running water for birdbaths and water drips for attracting birds, and when things slow down you can get a few other things done.

There are several things you can do to make your home turf an attractive habitat for the birds. The habitat must include a food supply, a water supply, and cover for safety and concealment. Modern-day builders tend to cut down everything, build a house, and put in a few small shrubs. Basically, the house sits like a lone meatball on a plate, and birds won't come near it because to do so they would be exposed for too long. Plant some bushes close to the house or to your feeders, and the birds will zip into them, then make short forays for food. With a refuge close by, many more birds will come. Ideally, you should plant food plants, which also attract birds. Many eat seeds and berries and will form the habit of dropping by, whether or not your feeders hold food. When you set out shrubs and bushes, bear in mind that you'll need a good background for feeder photography, and plant a bush or two accordingly. If you plan to do your shooting through a window, try placing a feeder 6 or 8 feet away and a shrub 3 or 4 feet beyond that. As to what kinds of plants to set out, check with *Songbirds in Your Garden* by John K. Terres (New York: Hawthorn Books). This book also comes in two volumes: East and West. East has just been completely revised. There is also an excellent little booklet, *Attracting Birds to Your Backyard*, available, free, from the National

YOUR HOME GROUNDS

Wildlife Federation (1412 16th Street, NW, Washington, DC 20036).

Include some flowers in your plantings, because flowers attract insects, and insects attract birds. Some flowers, like bee balm and devil's fingers, draw hummingbirds by themselves. With a little effort, you can make your home territory a popular spot for both resident and migrating birds.

PHOTOGRAPHING IN ZOOS

One of the best places to photograph birds is at the local zoo. A zoo offers a concentrated, continuously varying workshop where a photographer can practice many of the techniques necessary for field work. Local birds are generally well represented and offer a chance for close-range study that is of value when you work with the species in the wild. Admittedly, birds in zoos live under artificial conditions, and their behavior is not always the same as it would be under natural conditions; but the basic patterns remain the same. The behavior associated with curiosity or alarm will be similar to the same behavior in their wild counterparts. Certain postures and actions can easily be studied at the zoo and may indicate what the bird is getting ready to do. Tail-flicking, head positions, and general "expressions" may well tell you that your subject is alarmed and ready to run or fly; recognizing this attitude in the field will come in very handy.

There is a good deal more bona fide wildlife in a zoo than people realize. Migrating songbirds and waterfowl may discover that the zoo is a safe place where they can get free food, and so they stop in twice a year. Some birds may even spend the whole winter at a zoo. Often there are more "freeloading" wild birds than captive ones on a duck pond in winter. The visiting wildlife in a zoo is considerably tamer than it is in the field and tends to stay a little apart from the zoo specimens. This is helpful if you want to photograph black ducks, for example, without having other species of ducks, geese, and swans in the same frame.

To do a good job photographically, allow plenty of time for a zoo trip. I would consider four days the absolute minimum for large zoos, and a week would not be too much. Most zoos are cooperative toward photographers and are willing to help them whenever it is practical to do so. What few restrictions they have imposed are necessary and should always be observed. Breaking the rules, even if not dangerous, is not conducive to well-planned pictures, good public relations, the granting of any special favors, or a welcome when you come back the next time. Zoo keepers and attendants are there because they love the animals and love working with them. When you show a sincere interest in any of their charges, they usually go out of their way to help you get the good pictures you are after. Often the

staff members would appreciate a print if you catch some unusual behavior; many are photographers themselves. They may also have some special techniques to share with you.

Although zoos are a controlled environment, they can still pose some problems for the photographer that necessitate special techniques. Many birds are kept in wire-mesh enclosures, and at first glance the wire may seem to be such a drawback that you may decide that the birds are not worth photographing. There is a way to get past the wire problem, however. Try photographing with the lens wide open and held very close to the wire. You'll discover that the wire magically disappears. You will have a good photograph of the bird, with no cage front visible. With a single-lens-reflex camera you can watch the image as you stop down the lens and see just how far you can go; it may be a stop or two less than the maximum aperture before the wires begin to appear. After framing and focusing, keep your eye at the viewfinder and move the camera left and right, up and down, to see if the wire shows at all. If grayish shapes are evident, open the diaphragm a bit and center the bird in the clearest area.

Any place humans drop crumbs or throw away food is a good place to check for birds. This Florida towhee had formed the habit of checking a picnic area every so often. The photographer parked his car nearby, stuck a camera with a 200mm lens out of the window, and was ready when the towhee stopped by.

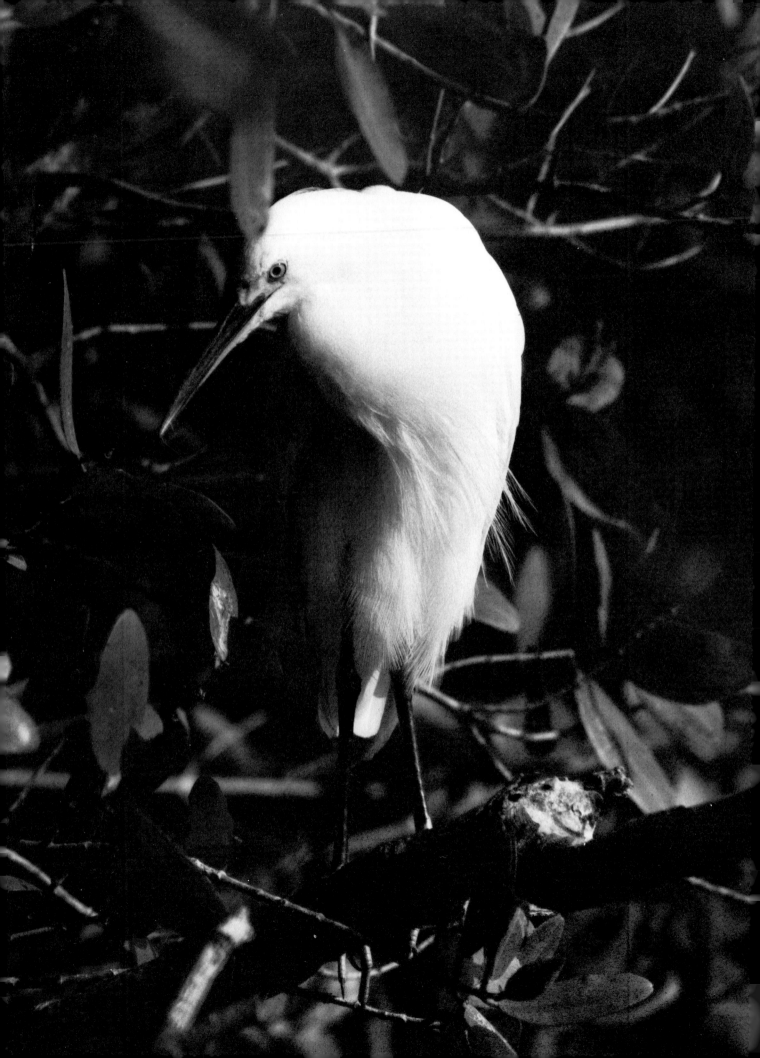

Large flightless birds such as rheas, emus, ostriches, and cassowaries are generally kept outdoors in pens and can be photographed with telephoto equipment. You may be tempted to use a normal lens and lean over the fence, but it's a risky operation. These birds peck at shiny objects like eyeglasses and can do a lot of damage.

Pinioned cranes, flamingos, ducks, and geese are all prime subjects that can be found in attractive zoo settings. Use a medium-length telephoto lens to cut out extraneous background objects and concentrate on the bird itself. Use a longer lens for portraits and close-ups.

The lighting in a zoo can vary widely. It may be daylight in one place, dim shade in another, or tungsten, fluorescent, or diffused skylight illumination. The wire on a cage cuts down on the intensity of the light entering the lens (sometimes as much as one full stop), and it also cuts down on the light striking the subject from a flash outside the cage. It can take a lot of practice, but zoo photography can be good for just that reason, as well as for its artistic value, science, humor, record purposes, information, or just plain fun. It is also one of the most convenient and enjoyable places I can think of to test a new lens or camera.

FARTHER AFIELD

When people think of photography, most think of a trip; it's fun to travel, after all, and traveling offers many more photographic opportunities than staying home. In planning trips, advice from others is valuable, but it may be hard to come by. That's when it's time to turn to "Pettingill"—specifically, *A Guide to Bird Finding East (or West) of the Mississippi*, by Olin Sewall Pettingill (Boston: Houghton Mifflin). These two volumes contain a staggering amount of information about the best birding sites, no matter where you are. It is arranged by states, with each species listed in the index with the states where it is found and the page references. It is also remarkably detailed. You will find such directions as, "Go down State Route 123 for 3.1 miles, then turn left on the dirt road just past the railroad crossing. Follow this till it crosses a creek, and park here. Check the thicket for sparrows and warblers. Look to your left, and hike toward the three large pines you see there. Now. . . ." The volumes are available in hardcover and paperback, and no serious birder should be without them.

There are often smaller, local guidebooks available covering just one state, or even part of a state. James A. Lane's *A Birder's Guide to Florida* and *A Birder's Guide to Southeastern Arizona* (Denver: L & P Press), and Noble Proctor's *25 Birding Areas in Connecticut* (Chester, CT: Pequot Press) are excellent examples. Check with the nearest Audubon Society branch or your local bookstore. Birding is now a popular enough sport that

Egrets have certain areas they favor over others. Often they skulk in the interior of mangrove bushes and may be hard to see, despite their snowy whiteness. You can be sure, however, that they will frequent areas with a good supply of minnows.

there are quite a few books on this and related subjects, and many booksellers have a bird section. While you're there, check to see if your field guide is so outdated that it should be replaced. The birds themselves don't change, but their ranges do; and you may find new species that weren't around when the older guides were printed. Roger Tory Peterson's *A Field Guide to the Birds* (Boston: Houghton Mifflin) is both the old standby and the definitive work on the subject. It comes in two volumes, for East and West; it has recently been completely revised and is better than ever. A one-volume field guide for the entire country is *Birds of North America*, by Chandler S. Robbins, Bertel Bruun, and Herbert S. Zim (New York: Golden Press). In both these guides, the text and illustration for each bird are placed on facing pages, which makes them very convenient for field use.

Aside from these general guides, there are many specialized guides, to birds of the oceans, the deserts, and every major country in the world. You will also find books on types or groups of birds—game birds, water birds, birds of prey, owls of North America, eagles, swans, robins, pigeons. You can amass quite a sizable library without any trouble at all.

Below. Anhingas like to stay close to good fishing waters, and the hungrier they are, the more tolerant of people and cameras they become. This one has just speared a small fish and allowed the photographer to get close enough to use a 200mm lens. Note how the bird's whole body is submerged with only head and neck above water—hence the name "snakebird."

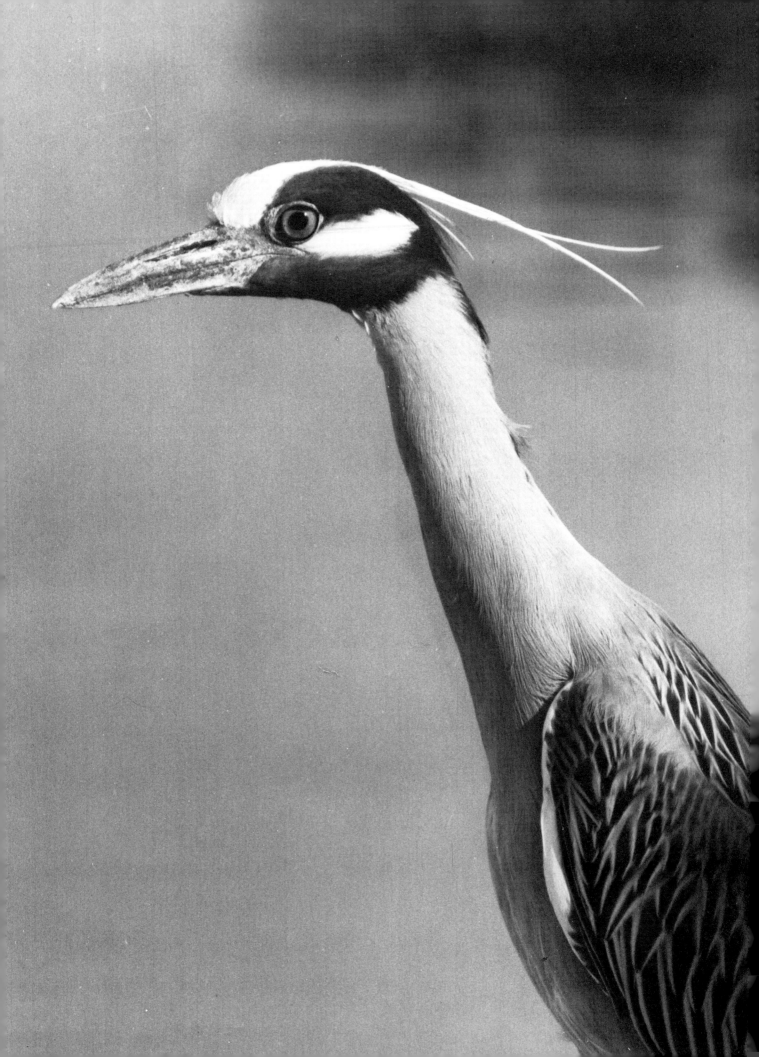

PARKS AND WILDLIFE REFUGES

Left. The head of an adult black-crowned night heron exhibits strong and distinctive markings seldom seen except closeup. The subject of this photograph was a wild, unconfined bird that had formed the habit of socializing with bridge fishermen and permitted humans to approach closely.

Below. Flocks at rest often make a pleasing pattern. You will find that birds usually have favorite rest spots.

But books aren't photography. Consider for a moment what the photographer really needs: a place that attracts birds, where they aren't molested and may even be fed, where they are accustomed to seeing people and vehicles regularly, where they are inclined and encouraged to become fairly tame. On all counts, the State and National Parks and Wildlife Refuges are by far the best places to spend your time. Check a map and see what you can reach comfortably in the time available; then check your Pettingill for a description of the spot and its bird life. You should also, when possible, consult a specific guidebook, like Jessie Kitching's *Birdwatcher's Guide to Wildlife Sanctuaries* (New York: Arco Publishing Co.), and also check with local birders who may know the spot; their information will be helpful, and you might want them to join you. If there's doubt about current conditions, pick up the phone and talk to the park ranger, naturalist, or superintendent. I've never found one who wasn't cooperative and helpful.

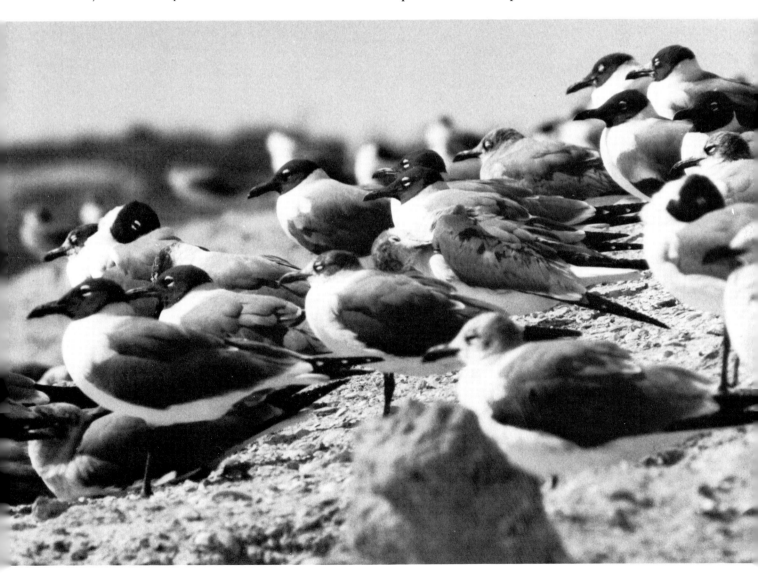

see more different warblers than at any other time in your life, and certainly at least a few Mexican species you're not likely to find elsewhere.

A bit farther east there's Rockport, on the Texas Gulf coast. It is known primarily for being the wintering grounds of the whooping crane—the *only* flock that exists, anywhere in the world. But Rockport has much, much more, impressive as the cranes may be. As you might expect, there are other water birds, other long-legged waders, sandhill cranes, herons, egrets. And there are shorebirds—curlews, dowitchers, sandpipers, plovers—and absolutely countless waterfowl. Would you believe the wintering geese are estimated to number 300,000? And then there are such things as pipits, hawks, thrushes, warblers, eagles, pyrrhuloxia, caracara, most of the common land birds, and during migration thousands of warblers. Connie Hagar, during her lifetime, saw well over 400 species around Rockport, Texas. It's quite a place.

Winter is the best time to visit, and it's the only time you'll see the whoopers. Weather naturally has a strong effect on the quality of birding. During inclement weather, migrating birds light on the first dry land they reach—the coast—and in their fatigue they may be ridiculously tame. Likewise, outbound birds may not start an overwater flight until conditions are good. You may see thousands of birds when it's stormy and wonder where they all went when the sun shines.

This effect is most noticeable when there is a large north-south peninsula along a migration route. Two such are Cape May in New Jersey and Point Pelee in Lake Erie, east of Detroit. There is a natural funneling effect that concentrates bird life, and added to that is the slowing or stopping effect of bad weather. The birds may fight for space on telephone wires, or perch on cars, porch railings, hats, and even people. One good day like this is something you'll remember for life—and no one

Ordinarily, you would plan to shoot birds in the air at a dump to avoid showing the ground. In this case, though, for a truly story-telling picture it was better to include the dump itself and the work that was drawing birds there.

would believe it without pictures to prove it!

For major trips in the continental United States, an informative and entertaining book is *Roger Tory Peterson's Dozen Birding Hot Spots*, by George Harrison (New York: Simon & Schuster). Both these men are wonderfully informed and share their knowledge with the reader. The book is about five years old, but it's very unlikely these dozen meccas will have changed much.

OTHER COUNTRIES AND REMOTE AREAS

There are fabulous spots for a birder outside of the United States. The allure of totally new species, as well as new surroundings and new cultures, makes a birding trip abroad even more enticing. Some of the best areas are well supplied with motels and convenient transport—East Africa, for instance—but others may be difficult or impossible to reach, and living conditions can range from uncomfortable to downright miserable. It's hard to remain an enthusiastic birder in a wet, cold sleeping bag, in a leaky tent, during a wild gale.

There's a very easy, very pleasant way to solve these problems, and it's summed up in two words: *Lindblad Explorer*. As you may know, this is a small ship operated by the Lindblad Travel organization, and its name has become a byword among the world's most ardent wildlife watchers and photographers. In a word, the *Explorer* goes where other ships *don't* go—to the Antarctic, to remote Pacific coral islands, and along the China coast. It is a small luxury liner, staffed with experts in the fields of ornithology, zoology, anthropology, history, botany—whatever sciences are appropriate to the region being visited. Before the trip begins, the destination has been carefully scouted, so the itinerary includes the very best that part of the world has to offer. For once the wildlife photographer in the field can be totally comfortable. Ashore, he or she may get as wet, cold, dirty, muddy, and bedraggled as the work demands—*then* it's back to the ship, with heat or air conditioning, a hot shower, tablecloths and silver on the table, waiters and bartenders—the best of two worlds. For a serious wildlife photographer with wanderlust, the only thing better than a once-in-a-lifetime *Lindblad Explorer* trip is several of them.

In summary, good bird photography involves the study and appreciation of a widely diverse, totally fascinating group of living creatures and the process of getting their images onto film. The best bird photography includes doing this artistically and informatively. Few people realize the effects birds have on their lives, since these effects are usually unseen. Fewer yet realize that, were it not for the world's birds, the insects would very probably get completely out of hand in a short time. Birds are worthy of our appreciation, and study—and are superb subjects for our cameras as well.

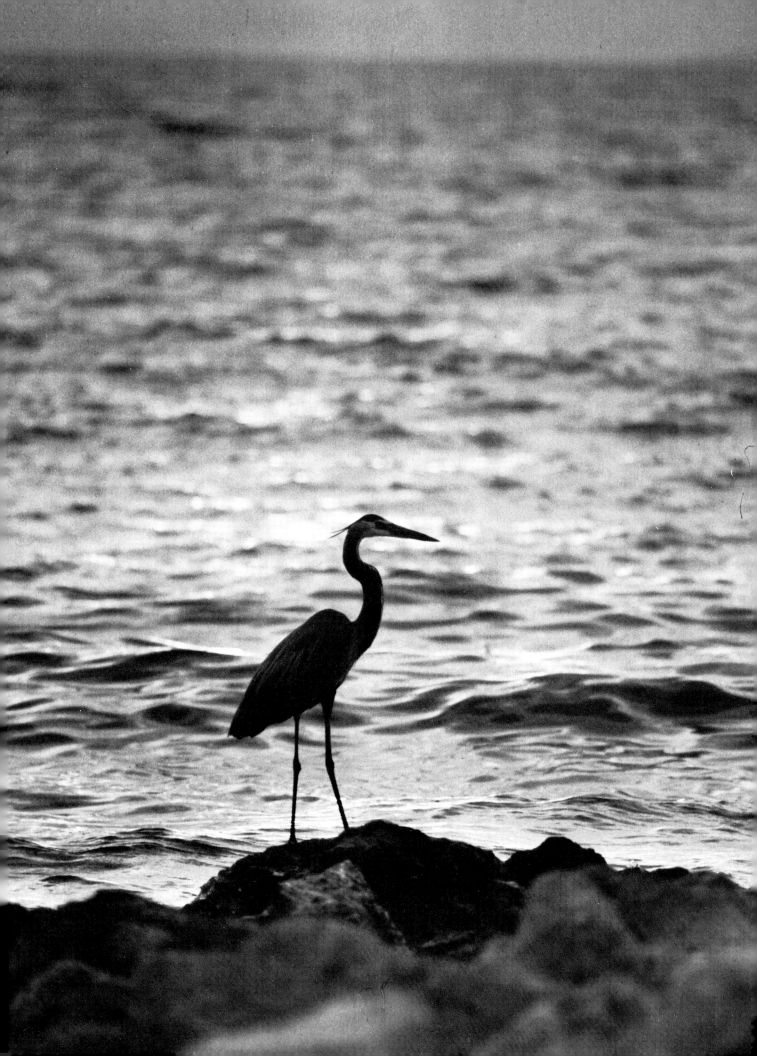

BIBLIOGRAPHY

Bennett, Edna. *Nature Photography Simplified.* New York: Amphoto, 1975.

Harrison, Hal H. *Field Guide to Birds' Nests.* Boston: Houghton Mifflin Co., 1980.

Holmasen, Ingmar. *Nature Photography.* New York: Ziff-Davis Publishing Co., 1976.

Holzman, Richard W. *Impact of Nature Photography.* New York; Amphoto, 1979.

Hosking, Eric John. *Wildlife Photography.* New York: Praeger, 1973.

Izzi, Guglielmo. *Complete Manual of Nature Photography.* New York: Harper & Row, 1981.

Kertesz, Andre. *Birds.* New York: Mayflower Books, 1979.

Kinne, Russ. *Complete Book of Nature Photography.* New York: Amphoto, 1979.

Kodak guide. *America's National Parks.* New York: Popular Library, 1979.

Linton, David. *Photographing Nature.* New York: Natural History Press, 1964.

Moon, G. J. H. *Photographing Nature.* Rutland, Vt.: C. E. Tuttle Co., 1970.

National Wildlife Federation. *Wildlife Country.* Washington, D.C.: National Wildlife Federation, 1977.

Peterson, Roger Tory. *Field Guide to the Birds.* Boston: Houghton Mifflin Co., 1980.

Peterson, Willis. *Guide to Better Nature Photography.* Beaverton, Or.: Beautiful America Publishing Co., 1979.

Pettingill, Olin Sewall, Jr. *Guide to Bird Finding.* Boston: Houghton Mifflin Co., 1980.

Robbins, Chandler S., Bertel Brunn, and Herbert S. Zim. *Birds of North America.* New York: Golden Press, 1966.

Slocum, Perry D. *Birds of North America and How to Photograph Them.* Winter Haven, Fla.: Florida Audubon Society, 1971.

Time-Life Books. *Photographing Nature.* Alexandria, Va.: Time-Life Books, 1971.

Villiard, Paul. *Through the Seasons with a Camera.* Garden City, N.Y.: Doubleday, 1970.

Wilson, Arnold. *Creative Techniques in Nature Photography.* Philadelphia: Lippincott, 1979.

LIST OF SUPPLIERS

The following is a list of places where you can find the various supplies that are often needed in the photography of birds. There are, of course, many more than are listed here. The first mention of any particular source includes the full name and address; subsequent mentions, only the name.

Air-releases—*Your local camera store, or Spiratone, Inc., 135-06 Northern Blvd., Flushing, NY 11354 (800-221-9695).*

Backpacks—*Biking, hiking, skiing shops.*

Belt pouches—*Sew up at home using vinyl material from auto-top, upholstery, or boat-cover shops.*

Bird blinds—*George Lepp & Associates, Box 6224, Los Osos, CA 93402.*

Bird calls ("squeakers")—*Local or National Audubon Society, 950 Third Ave, NY, NY 10022.*

Bird feeders—*Advertised in Audubon magazine.*

Cameras, lenses, film—*Your local camera store. Make a friends of the owner. Also check discount stores—but don't expect much in the way of service.*

Camouflage cloth by the yard—*Kaufman's, 504 Yale St. NE, Albuquerque, NM 87106.*

Camouflage clothing—*Army-navy, sporting-goods stores.*

Changing bag—*Camera store or Spiratone.*

Clampod—*Ditto.*

Crosstar filters—*Ditto.*

Decoys: owl—*Sporting-goods, marine-supply stores.*
 duck & goose—*Sporting-goods stores.*
 gull—*Homemade.*

Dichroic polarizers—*Spiratone.*

Diffraction gratings (Rayburst filters)—*Spiratone.*

Fanny pouch—*Hiking, biking, skiing shops.*

Filters, filter rings adapters and accessories of all sorts—*Spiratone*

Foam plastic—*Check the Yellow Pages.*

Inexpensive high-quality photographic gear—*Forget it.*

Information: electronic—*Local electronic store maybe, otherwise—nearest high school or college faculty.*

Information: biological and ornithological—*Ditto.*

Lindblad Explorer information—*Lindblad Travel, 8 Wright St, Westport, CT 06880.*

Light-beam-tripper—*Plans from local electronics whiz; or the author.*

Lithographic film—*Large camera stores, graphic-arts supply stores.*

Microswitches—*Local electronics store, or, if you're lucky enough to find a junked pinball machine, they're loaded with them!*

Multiple prisms—*Camera store or Spiratone.*

Pop-tents—*Sporting-goods or beach-toys store.*

Shoulderstock—*Camera store.*

Small flashes—*Camera store or Spiratone.*

Stack-caps—*Spiratone.*

INDEX

Edited by Michael O'Connor
Designed by Jay Anning
Graphic production by Hector Campbell